What people are

After the Grea

Mikkel Bolt Rasmussen's *After the G.... Refusal* is a trenchant critique of neo-liberal domination of contemporary art. Incisively analyzing relational aesthetics, interventionist art, new institutionalism and postmodern architecture, Rasmussen renews Marxist critical theory and holds open the promise of radical culture "after the self-murder" of the artistic avant-gardes.

Gene Ray, author of *Terror and the Sublime in Art and Critical Theory*

Informed by Western Marxism and the avant-garde, and combining in-depth analysis of specific cases with historical insight and theoretical rigour, Mikkel Bolt Rasmussen thinks through contemporary art's manifold and deepening contradictions. Art's *promesse de bonheur* has been coopted and corrupted to an extent that likely would have horrified even Adorno and Marcuse—though it would not have surprised Debord—while the revolutionary Long March Through the Institutions has become a series of desperate compromises. Refusing to be satisfied with mourning a radical past and condemning a dismal present, Bolt sounds out how contemporary practice and theory can offer openings and create forms with a future—forms of futurity.

Sven Lütticken, author of *Cultural Revolution: Aesthetic Practice after Autonomy*

In a time of headlong social and biophysical "dissolution into capital", social reproduction crashes and dark political phenomena spring up on all sides. Friendly phantoms of reform surface here and there with their jolts of short-lived radical affect,

while fascist libidinal economies go to work on everything from urban cultural life to state power. Meanwhile art institutions mind the crisis by widening the sphere of representation without traction that has long been the modus operandi of their stability. Rather than deploy cultural theory's well-worn genres of determinist allegory or fractal anecdote, Mikkel Bolt offers precision analysis grounded in the constitutive contradictions of the fact that art is a form of autonomy derivative of the value form, yet a space which can still figure social experience that goes through and past it into a non-capitalist time. Surveying art, architecture and revolutionary theory from the past half-century, *After the Great Refusal* makes a strikingly historical and sharply material argument in favour of negation and abolition as the only imperatives that still make any sense.
Marina Vishmidt, author of *Reproducing Autonomy: Work, Money, Crisis and Contemporary Art*

As much as I hate art, I really loved reading the book. That may have been the point. Could also be my blurb.
Joshua Clover, author of *Riot. Strike. Riot*

After the Great Refusal

Essays on Contemporary Art, its
Contradictions and Difficulties

After the Great Refusal

Essays on Contemporary Art, its Contradictions and Difficulties

Mikkel Bolt Rasmussen

Winchester, UK
Washington, USA

First published by Zero Books, 2018
Zero Books is an imprint of John Hunt Publishing Ltd, Laurel House, Station Approach,
Alresford, Hants, SO24 9JH, UK
office1@jhpbooks.net
www.johnhuntpublishing.com
www.zero-books.net

For distributor details and how to order please visit the 'Ordering' section on our website.

Text copyright: Mikkel Bolt Rasmussen 2017

ISBN: 978 1 78535 758 9
978 1 78535 759 6 (ebook)
Library of Congress Control Number: 2017944395

A CIP catalogue record for this book is available from the British Library.

Design: Stuart Davies

Printed and bound by CPI Group (UK) Ltd, Croydon, CR0 4YY, UK

We operate a distinctive and ethical publishing philosophy in
all areas of our business, from our global network of authors to
production and worldwide distribution.

Contents

Acknowledgements

As always, there's a collective behind an individual signature. This is also the case here. So, many thanks to many people. First and foremost, to Katarina Stenbeck, whose continuous engagement in contemporary art has forced me to continue thinking about it. But also thanks to the many friends who have given me support and inspiration along the way. Thanks especially to Jakob Jakobsen, Jørgen Michaelsen, Carsten Juhl, Gene Ray and James Day.

Early versions of the chapters in the book have appeared in various journals and catalogues. Thanks to Rasheed Araeen, Anthony Iles, Jacob Lund, Marc James Léger, Cecilie Hundevad Meng Sørensen and Kristin Veel for their engagement and hospitality. "The Double Nature of Contemporary Art" was originally published as "Scattered Remarks (Western Marxist-style) about Contemporary Art, Its Contradictions and Difficulties" in *Third Text*, vol. 25, no. 2, 2011, pp. 199–210. "The Self-Murder of the Avant-Garde" was printed under the title "The Self-Destruction of the Avant-Garde" in Marc James Léger (ed.) *The Idea of the Avant-Garde And What It Means Today* (Manchester University Press, 2014) pp. 121–130. "After Credit, Winter" appeared in Swedish in *Paletten*, no. 288, 2012, pp. 6–13 and then in English in *Mute*; http://www.metamute.org/node/6119. "The Long March Through the Institutions" is forthcoming in *Navigation*, edited by Cecilie Hundevad Meng Sørensen, Samuel Richter and Hinrich Sachs. "Globalization, Architecture and Containers" has been published as "Advertising Architecture and Containers: The Hidden World of Logistics and Spectacular Architecture" in Annie Ring, Henriette Steiner & Kristin Veel (eds.) *Architecture and Control* (Leiden: Brill, 2018), pp. 209-227. "Imagining a Future" was first published as "A Nightmare on the Brain of the Living: Repeating the Past and Imagining the Future", in: *Nordic Journal of Aesthetics*, no. 49/50, 2015, pp. 91–117.

Introduction: Against the Established Taste

This book is about contemporary art. Contemporary art and the different frameworks within which we understand it: historical developments, institutions, criticism and ways of reading. It is not a systematic exposition; nor is it characterized by a unified voice. The reader must make do without such reassuring measures. Contemporary art, the avant-garde and critique are recurring figures, but the text is fragmented, situated in accordance with the conditions of possibility of knowledge production today, where instrumentalization is *a priori* and the university so pervaded by economic categories that even defence of Enlightenment ideals of *Bildung* appears to be a radical stance.

The texts in the book are expressions of turbulent times, where academic research is forced from the shelter of its already ruined ivory tower. The patient, academic, sanctioned analysis that is present at times in the book's essays is thus necessarily expanded or replaced by a more explicitly political discourse. Descriptive utterances merge with performative statements, in which the distinction between academic and political analysis tends to dissolve. In the present situation there is no other way. Texts that do not address the accelerated chaos in which we are living are of no use. In that way, the texts in this book say something about the conditions for critical analyses today. They say something about the urgency and scope of the crisis. Everything is breaking down — a prolonged economic crisis, the return of fascism, geopolitical instability and biospheric meltdown are interwoven processes that put pressure on the analysis and annul any pretence of scientific certainty.

Crisis and breakdown, disruption and meltdown. If history ended in 1989, it has surely been accelerating since 9/11, 2008, 2011 and 2016. Globalization became a state of emergency. The Erinyes are hounding all and sundry, there's no equilibrium and

it's impossible to predict what will happen. The certainties of yesterday have shown themselves to be built on air and paper money. The economies of the BRICS (Brazil, Russia, India, China and South Africa) that were supposed to come to the rescue of the world economy after the collapse of 2007–2008 were quickly shown to be founded on credit bubbles themselves. The International Monetary Fund and the World Bank are nervously following the development. Gigantic growth in China, which was a central part of neo-liberal globalization, where Chinese workers produced cheap commodities for the indebted workers of the West, whose debt was in the last instance guaranteed by the Chinese state bank's buying up of US state bonds, has not only dropped off significantly, but has also been shown to be supported on risky loans itself.

In the US, it is becoming difficult for the ruling class to keep a lid on the situation. The financial crisis revealed enormous national inequality resulting from the 40-year-long hollowing out of middle-class household economies, making it difficult for the two political parties to control the political public sphere. Trump is the best expression of this development, of course. But phenomena like Sanders, the Tea Party movement, Occupy and Black Lives Matter are all challenges to the system's same old, same old.

It is not much better in Europe, where the combination of tough austerity programmes, and fleeing revolutionaries from Syria and the Middle East, and migrants from Africa, have thrown the EU into crisis. In several countries near empty coffers are scraped even barer, and racist solutions are being tested and integrated into state policy across the board. The UK is leaving the EU, Spain is in a state of apparently perpetual political chaos; in Germany, Angela Merkel is challenged by a resurgent right-wing nationalism and in France, the old parties have broken down and large parts of the youth have simply deserted national democracy. Everywhere, political, economic and climatic chaos

are fusing into an opaque web, where it is very difficult to see what's up and what's down, and where it is easier to see what's falling apart than what is emerging.

The crisis is seriously questioning previous practices, beliefs and commitments. The relative autonomy that art and academia have been equipped with for the last 200 years is under tremendous pressure from both within and without. From the inside, the promise of happiness is forcing art into avant-gardist transgressions or revolutionary engagements in the ongoing struggles against power and capital. From the outside, the culture industry is threatening to realize art upside down as an expanded participatory experience economy. When it comes to academia, the commodification of education, research and knowledge appear almost complete.

Communism / Art History / Whatever

The book consists of essays, which is to say attempts. Attempts of writing where through different objects, artworks or problematics, I try to describe the critical potential of contemporary art and its way, or not, of articulating criticism. The tentative nature of the thing somewhat resembles a musician who, before a concert, tests her instruments and listens: Is it working? How does it sound? What kind of space is it? The essays in the book are just such tests; I strike a note and listen. Does it work? Is there overdrive? But the essays in the book are also meant as interventions, to be offensive or antagonistic towards their contexts, big and small, to both the relative autonomy of contemporary art and neo-liberal capitalism. If there's an element of "music" in the book, there's also a certain amount of "activism". Testing but also confrontation then, where the self-evidence of contemporary art is questioned.

The critique of contemporary art is, of course, supposed to be a critique of the present society, where contemporary art functions as a prism for a larger analysis. Contemporary art

as a representation of the present as history. The analysis is an attempt at breathing life into a particular kind of interpretation one could call Western Marxist. A Marxist cultural critique that maintains a base and superstructure model not as a conclusion, but as a fragile starting point for the analysis of how the forms of aesthetic experience are mediated by the rhythms of capitalism.

It is not a question of a simple analogy between culture and capitalism but a mediation, a translation or a representational form. History as a formal effect of an absent cause, as Frederic Jameson writes following Althusser and Spinoza.[1] This is why Jameson analyses postmodern culture as a challenge to our ability to map the totality. It's the disappearance of the ability to create a representation of the present. Culture mediates this fragmentation, the opposition between whole and part, their incompatibility. The task of Marxist cultural critique is to develop an analysis that can represent the complex and uneven "geography" of global late capitalism.

You could also say that late capitalism is in a state of permanent crisis and that contemporary art "expresses" this crisis. Saying that, of course, risks inscribing a trajectory of decline into the analysis, but the crisis is constitutive, so to speak. It is already there in Benjamin, Adorno, Debord and the others. This has to do, of course, with capitalism and its revolutionary mode of production that renews itself incessantly; expands, liquidating on the way not only institutions and apparatuses, but also forms of solidarity and senses of community, creating new ones that are then dissolved and replaced by new ones again. "All that is solid" and all that. From Marx to Debord to Robert Kurz: capitalism is a Moloch that colonizes more and more aspects of human life, recreating the world in its own picture. Almost everything is mediated by the commodity form and all social relations are put in the real metaphysical service of an impersonal economy.

This vertiginous movement is in a sense one long crisis that modern art registers and interprets, and therefore the crisis

is the material all the way from Baudelaire and Mallarmé to Benjamin and Debord, and onwards to Manfredo Tafuri and Jameson, and T.J. Clark. Capitalism is not just modernization and development, it is also crisis and underdevelopment, "the combined and uneven development" Trotsky described, where general underdevelopment is hidden behind conjunctural upturns in consumption for a select group.[2] The development in the West after World War II up to the 1970s was just such an upturn. While we in the West experienced a tremendous economic and sociocultural recovery, the rest of the world was to a very large extent mired in underdevelopment. Even the enormous growth in China since the mid 1980s is in reality the pauperization of a far larger number of peasants and workers who have been wrested free from pre-capitalist means of existence—"dissolution into capital" as Marx termed it.[3]

(A)Political Aesthetics

In *Bad New Days*, Hal Foster writes that contemporary art is so vast and diverse, and so present, that it can be difficult to give an overview of it.[4] The essays in this book are nonetheless a contribution to the mapping of contemporary art caught between expansion and conformity. Contemporary art is a highly composite and heterogeneous object, of course. One that institutionally includes everything from politicized artist-run exhibition spaces to large commercial galleries or art fairs.

In Copenhagen, for instance, "contemporary art" encompasses such different institutions as the privately owned 1500 square-metre exhibitions space Faurschou Foundation, on the harbour front in Nordhavn, where international bestsellers like Louise Bourgeois or Ai Weiwei show their massive installations. But it also includes CAMP, an exhibition space in a shelter for asylum seekers and migrants in outer Nørrebro.

In between, we have small and large museums, all of which are confronted with the need to attract tourists and function as

places for some kind of cultural education, national or not. Also the *kunsthalles*, which not only service the local art scene, but also present international contemporary art, including more politicized exhibitions.

Then there's the commercial galleries that not only have to earn money, but also sometimes present artists who have some kind of real or imagined political engagement. And, of course, there's all the artist-run spaces that often have a more experimental or process-based character, at least in Copenhagen.

There's the School of Fine Arts, with all its students and teachers—a place of great importance when it comes to reproducing the local milieu. And then we have the university, where contemporary art gets discussed and analysed, and the media, newspapers and the local journals that deal with contemporary art. This "local" scene is, of course, connected in many different ways, both institutionally and personally, to a long list of other art milieus and the so-called global art institution.

Altogether this is a very layered and composite scene that carries out a range of often contradictory functions under pressure from "outside" forces and developments. With Pierre Bourdieu, we can call it a field, a social micro-cosmos, where the development of artistic production is driven by conflicts between actors who fight for field-specific recognition.[5] The "internal" fight for recognition that, historically, is the inversion of the dominant economic logic, which is always put under pressure by the very same "external" economic logic. Art is thus characterized by autonomy, but also heteronomy, Bourdieu says. And the external pressure has only augmented. If there's a development that has been significant during the last 25 years, it is without a doubt that the production, circulation and reception of contemporary art have become much more fully integrated into the culture industry.

After the fall of the Berlin Wall and especially since the late

1990s, the art market has not only tended to acquire a hegemonic status in contemporary art, but contemporary art has also become part of an expanded experience economy, where art has fused with cultural tourism, pop culture and gentrification. The explosion in the number of biennials and the erection of one more spectacular museum after another is the most visible expression of this development. This is what Foster calls the "Bilbao-effect", where cities and museums compete in attracting visitors and sponsors through spectacular buildings and large-scale art events.[6]

This is a global trend, from Frank Gehry's Guggenheim Bilbao, where computer-aided design paved the way for urban regeneration, to Olafur Eliasson's *New York City Waterfalls*, where aesthetic sensory experience brands the city. Art reduced to cultural tourism. To the booming finance capital, art was an obvious thing to invest in and a large part of the art institution thus became part of the transnational network of capital, where the 1 per cent invested in stocks and artworks, instead of factories and production.[7]

It is important, of course, not to become hypnotized by the sudden inflow of paper money and analyse it as an expression of a decisive new development that finally pulls the rug from under contemporary art's supposedly transgressive potential. This confirms once and for all that art has sold out or become nothing more than a luxury good for the 1 per cent. As we know from avant-garde and modernist Marxists like Adorno, Marcuse and Debord, this is part of a much longer development, in which a shift occurs in the relationship between art and economy over the course of the 20th century.

"Culture industry" and "spectacle" are attempts to come to terms with this development, where modern art somehow becomes a part of "the base", is integrated into capitalist economy.[8] Adorno and Debord agreed that any attempt to update the critical analysis of capitalist society had to account

for the expanded domain of cultural production. Mass cultural production and consumption became as "economic" as the productive spheres, and just as much part of capitalism's generalized commodity system. It is thus not a new phenomenon we are confronted with, but its contradictions have become more enhanced.

If we zoom in and look at the art institution from the inside, from within the framework of its relative autonomy, we can, on the one hand, observe the art institution as a space for political discussion and militant actions that rarely takes place elsewhere. This is also why artists and cultural producers played a leading part in Occupy Wall Street in New York in September 2011, for instance. On the other hand, contemporary art is the window dressing and sale of only apparently critical utterances or forms that in no way challenge the ruling taste. On the contrary, contemporary art has become indistinguishable from all the other forms of aesthetic entertainment. Contemporary art is no longer just a research and development unit of advanced capitalism. Instead, it is part and parcel of an all-encompassing experience economy on a level with advertising, fashion, music, TV and games.

The contradictions are obvious. On the one hand, exhibitions like D11 and the Venice Biennial 2015, both organized by Okwui Enwezor, thematized ongoing political conflicts with a view to establishing a genuinely autonomous postcolonial perspective. On the other hand, the very same exhibitions' use of unpaid and precarious labour, and their dependency on sponsors like Volkswagen, Sparkassen-Finanzgruppe and Deutsche Telekom, is conjoined with the obvious function of the exhibitions as city branding and as a destination for millions of cultural tourists. When you see Roman Abramovich sail his 162.5 metre-long and 340-million-euro yacht up to the Giardini to participate in the opening of the Venice Biennial, the conclusion almost necessarily appears to be that art is autonomous only in order for certain

objects to be defined (shown and sold) as artworks. Art is art with a view to profit (and the entertainment of the super rich and the global middle class).

The presentation of political statements works perfectly in this context as a kind of icing on the cake. Nobody is going to change their life because they have watched a 2-hour long documentary about the conflict between India and Pakistan at Documenta, anyway. The cynical reading of the presence of political representations in contemporary art must be that we have to do with a kind of representational politics. The political is visualized as the exotic other that the art institution necessarily includes in order to live up to its autonomy. A real transgression rarely takes place. What we get instead is a representation of politics as/in art. As Brian Holmes once stated laconically, when people talk about politics in art, they are lying.[9]

The narrative of contemporary art must focus on the extreme marketization and instrumentalization that has taken place during the last couple of decades. But it must also, necessarily, be about how contemporary art has been the place where political conflicts have been made visible and discussed in a manner that has seldom been the case elsewhere, as the remnants of a former Left public sphere have been destroyed, and politics reduced to what Jacques Rancière terms consensus, where there is what there is.[10] This is the story of contemporary art as a space of political engagement and critique of the system. Even though the relative autonomy of art is under pressure and is changing, the artistic field and the individual artwork are still characterized by being partly outside the capitalist logic of production and administration. And this partial separation, its relative autonomy, still equips art with a transgressive potential.

This is one of the explanations why we have seen art—in other words, institutions of art—be a place for different kinds of institutional critique, political curating and ambiguous escape attempts, where artists and cultural producers attempt to redirect

the potential of art, and connect it to extra-artistic formations and movements. This does, however, remain an exception, as most practitioners prefer to exhibit political representation inside the framework of the art institution. Not many leave its comfortable habitus, but it does happen. The alter-globalization movement and Occupy are events where art is embedded in broader political movements, and the professionalized gesture of art is expanded and becomes creative dissensus outside.

A Promise of Happiness

In the analysis of the contradictory character of contemporary art it is thus important to emphasize the historical process that shows us that the contradictions are, so to speak, constitutive. That is one of the lessons from the Western Marxist reading of modern art. Marcuse talked about the "affirmative character of culture", describing how art is both able to articulate a radical critique of capitalist society and at the same time to function affirmatively within the very same society. On the one hand, art's autonomy gives the artist a freedom that is an expression and a promise of a liberated human practice beyond commodity exchange and capitalism's other forms of domination, where art and the artwork criticizes the existing unfree society. On the other hand, as a separate sphere and gesture, modern art legitimizes the society in which it exists. As Marcuse puts it, autonomous art is affirmative because it is "compatible with the bad present".[11]

Peter Bürger talks about the artwork having no social effect.[12] Within the framework of Bürger's Critical Theory-inspired analysis it is, of course, this doubleness that constitutes the starting point for art's "self-critical phase". In other words, the historical avant-garde and their attack on the art institution, and their attempts to transgress artistic autonomy and realize art's freedom outside the institution as a part of a broader transformation of human life; that is, as a part of the revolution

and the abolition of capitalist society. While more and more areas of human life were subjected to the master logic of capital accumulation, art escaped and became a zone where the anarchist imagination that had disappeared in the rationalization of modern life survived in a suspended form.[13]

When we look at contemporary art and cannot make head nor tail of it, we are in fact looking at historically specific conditions that are related to much more than "art" in any straightforward sense. As I have already mentioned, the contradictions are constitutive. They have to do with art as an institutionalized phenomenon in capitalist society. As a relatively autonomous sphere, art is both a challenge and a confirmation of capitalist society, and the abstract domination of the value form. As Adorno says, the value form is the historical condition of possibility of autonomy.[14] This does not mean that art is merely ideological (in the bad sense). It has kept some of the emancipatory logic of its historical origin and, at least in negative, reflects a promise of happiness, *une promesse du bonheur*, as Adorno and Marcuse write (quoting Stendahl).

There is something subversive about art—it is a kind of rebellion. It is thus not enough to make visible the aporia—art undermines and confirms that society, culture and barbarism are closely connected—no, the aporia is somehow to be analysed and superseded. It is precisely not ahistorical, an invariance, but is historical and can thus be transformed. Or, as Debord would perhaps put it, art is revolutionary (or it is not). This is the problem.

Obstinancy

But as we know, all the revolutionary experiments of art and the revolutionary working-class assault on capitalism have failed. The 19th and the 20th century have been one long discontinuous panoply of collapses and breakdowns, where revolutionary theory has either been brutally crushed or has been turned into a

nightmare, reproducing the oppression it was meant to fight. In the last decades of the 20th century, the dream of another world appeared almost lost to eternity. The end of history was realized as the Washington Consensus and neo-liberal globalization.

Thinkers and historians like Francis Fukuyama and François Furet competed in declaring the 20th century over, laying communism to rest in history. The idea of a radical transformation of society only survived as an individualized injunction to live up to the shifting demands of the market and participate in capitalism's do-it-yourself consumption. Revolution was self-development, and identity politics and exchange value remained the unsurpassable horizon.

Everything is measured in money. In most Western European countries, the health authorities are now measuring health on the basis of the so-called quality-adjusted life year, where you price a year of human life and divide life quality with the cost of a treatment. The economization of life is complete! God is dead, long live money! We are truly living in a cliché of the Middle Ages, where money is the measuring stick of everything, there's no end to superstition and the ruins are piling up everywhere.

Things are falling apart. There's chaos, wars and epidemics all over the place. The economic crisis has turned into a political crisis. Neo-liberalism has suffered an ideological breakdown and different fascist solutions are being tested out across the continents. The capability of the ruling classes to prevent any serious challenge to the existing order and to capitalism has the upper hand for now. The most important thing is to prevent the crisis from becoming a revolutionary upheaval. Art cannot, of course, solve anything, but it does perhaps present itself as a kind of signpost in so far as it is never really itself, but always becoming different, always expanding, and in that sense open for the new.

Chapter 1

The Double Nature of Contemporary Art

Let us, if only for a brief moment—even though it may be cracking nuts with sledgehammers or just far, far too late—look at contemporary art in the light of the Western Marxist idea of art as an instrument of resistance, what Herbert Marcuse called "the great refusal" and Debord named "the art of change".[1] What do we see? On the face of it, it doesn't look particularly good. The traditional forms of intellectual and aesthetic opposition no longer to seem to be available. Visual images, as well as words and music, appear to lack their former alienating effect and are rarely antagonistic towards the prevailing order. Wherever we direct our gaze, it is mostly the complicity of the art institution with established power that is conspicuous.

The speculation economy of neo-liberal capitalism pumped huge sums of money into the art market after 1989, with the result that art today is closely tied to the transnational circulation of capital. At the same time, national governments, provinces and cities use art as a marketing instrument in the febrile competition for investments and tourists. These developments towards an ever-closer link between art and capital, and between art and the ruling order, are undoubtedly the predominant tendency when it comes to contemporary art.

But at the same time, it is important to point out that the space of art is still characterized by the presence of various representations of the political and attempts to use the field of art as a starting point for the visualization of conflicts that have been marginalized in the broader public sphere. For example, "political" exhibitions are held regularly, and even large institutions here and there have facilitated "political" exhibitions, and presented (artistic representations of) "art-external" themes.

In a quickly compiled list of just some of the important ones from the

last 10 to 15 years, the following comes to mind: "The Short Century: Independence and Liberation Movements in Africa" at Museum Villa Stuck, Munich and PS1 in New York; "The Interventionists" at MASS MoCA; "Communism" at the Project Arts Centre in Dublin; "Populism" at the Museum for Contemporary art in Oslo and Frankfurter Kunstverein, among other venues; "Revolution is not a Garden Party" at the Trafó Gallery in Budapest and Galerija Miroslav Kraljevic in Zagreb, among other venues; "Signs of Change" at Exit Art in New York; "Asking We Walk: Voices of Resistance" at Den Frie Udstilling in Copenhagen; Creative Time's "Living as Form" in New York; the 7th Berlin Biennial "Forget Fear" and "Soulèvement" at Jeu de Paume in Paris. The list is long. Since the end of the 1990s, there has been a greater interest in collective and antagonistic art, and art activism projects, which have been invited into art institutions and have been made the object of major exhibitions.

If we take the big biennials and Documenta as signposts, in the period after 1989 we can observe a movement from the highly traditional exhibitions of the early 1990s—with a preponderance of paintings by middle-aged white men, Jan Hoet's Documenta IX in 1992, for example—to the globalization-critical and postcolonial exhibitions of the late 1990s and 2000s. This occurred at Okwui Enwezor et al.'s Documenta 11 in 2002, where an attempt was made to start an explicit shift away from the prevailing colonial art-historical and political hierarchy. It is also where contemporary art, in an interaction with critical philosophy, urbanism and economics, mapped out the challenges and possibilities of the postcolonial era.[2]

Of course, many of the exhibitions that have been described as "political" have been so only in a very limited way. Often, the reference to the "political" and the inclusion of activist projects has most of all been a sales gimmick. An attempt to "comply with the wishes of the museums, the periodicals and the market for a visual representation of the political" or, quite simply, a move to disable any potentially radical gesture.[3] Nevertheless, there have been attempts to draw attention to pressing political issues and even to contribute

to ongoing political struggles or to challenge the way we think about them.

However, such exhibitions have been confronted with the problem that they take place in the absence of a political context in which the projects could potentially have a meaning beyond the enclave of the art institution. Paradoxically, it looks as if parts of the art institution are full of representations of political conflicts and struggles because, by and large, they do not appear anywhere else. There is no global progressive political public sphere for new thinking to articulate modes of resistance and discuss effective strategies for curbing the implementation of the new anti-dissent regime that is developing across the world, from Copenhagen through Athens to Gaza. This is meant to ensure that the well-heeled survive the crises and catastrophes ahead, whether they take the form of terror attacks, immigration or climate disaster. In the absence of viable radical political projects, it seems to be at the margins of the art institution that counter-paradigms and political alternatives are being kept alive, if in no other way than as images of conflict.

Contradictions

What this all means is that we are dealing with a situation full of contradictions; and, of course, that was part of what Benjamin, Marcuse, Lefebvre and the others registered in their critical analyses of avant-garde art, and its ambivalent problematizing of the autonomy of art in the first half of the 20th century. They were all so keenly aware that modern art involved a *promesse de bonheur*, pointing beyond established bourgeois capitalist society, while at the same time confirming it.

This was what Marcuse crystallized in his formulation about the affirmative character of art. On the one hand, the autonomy of art equips artists with a freedom that is both a proclamation of a free praxis in a free society and a critique of the existing unfree society. On the other hand, modern art always legitimizes the society in which it exists. As Marcuse writes, the independent sphere of art is affirmative,

15

since it is "compatible with the bad present".

This dialectical duality was the platform for the attack launched by the historical avant-gardes on the art institution, and their paradoxical attempts to overcome artistic autonomy and realize the freedom of art outside its institutional base as an element in the radical transformation of human life. The anarchistic imagination that had hibernated in art, but disappeared in the rest of human life because of modern life's rationalization, was to be unleashed and made available to all. But, as we now know all too well, the ambitious project of the avant-garde did not succeed. As with the concurrent revolutionary movement, the counter-revolution took over and transformed everything, with a view to making it the same as before. The grand attempts of the avant-garde to break down the boundary between art and life turned out to be no more than an immanent negation of the autonomy of art, not the desired revolution.

In retrospect, it is the institution's ability to subsume even extremely radical attempts to break away that remains when we cast our gaze over the art of the 20th century. The anti-art of the avant-gardes entered bourgeois capitalist society and strengthened it— this was the conclusion of the subversive avant-garde of the 1960s, the situationists, and the most keen-sighted and therefore resigned avant-garde theoreticians of the 1970s, Peter Bürger and Manfredo Tafuri, when they looked back at the fate of the interwar avant-gardes. The avant-garde had not been dealt a fair hand: established taste went to work to recuperate or derail everything with which it was confronted, large and small. Nothing was to be allowed to stand alone; everything was to form part of the spectacle.

The culture industry and the spectacle, today

Not only are we familiar with the contours of this development under the aegis of recuperation from the theory of the avant-garde, but also from a number of the central texts in the art-oriented part of Western Marxism. Texts include Adorno and Horkheimer's chapter on the culture industry in *Dialektik der*

Aufklärung and the situationists' excoriation of Godard in "Le rôle de Godard".

The two Germans analysed how autonomous art was integrated into the culture industry. According to Adorno and Horkheimer, capitalist production and the logic of administration subsumed art into commodity production, and thus suspended art's inherent resistance to alienation and exchange value. The issue that Adorno and Horkheimer outlined is no less pressing for us today, when art and culture, even more than in the 1940s, have become important markets, with a plethora of niches and differentiated commodity-based styles, and when contemporary art functions quite plainly as the R&D department for the other branches of the culture industry.

As part of the neo-liberal offensive that swept across the world from the end of the 1970s, there was an increased mercantilization of the art institution: even if it did not directly have to live up to a profitability requirement, it at least had to cast off the last vestiges of its autonomy. This was not only to cooperate with the business world, but also to take it as a model, and implement private industry's notions of efficiency and quantifiability.[4] This could be done, among other ways, by making sure that art institutions attracted investments that could contribute to the cultural tourism and urban beautification projects, which were an integral part of the gentrification processes that played an important role in the neo-liberal restructuring of many big cities. Such an activation or animation of the city, where art made it an event, was a dream come true for the production managers of neo-liberal capitalism.[5]

As Julian Stallabrass writes in *Art Incorporated,* neo-liberalism made perhaps its most explicit impact on art institutionally in the mega-exhibition and the biennial, which can in many ways be regarded as a supermarket for freely circulating artworks without historical depth and regional specificity: global contemporary art as a kind of universal brand that effectuates a homogenization and hollowing out of differentiated cultures, and replaces history with global spread, as if this were a guarantee of difference rather than a disguise for the

market's inevitable standardization.[6]

In their analysis of Godard's films, Debord and the situationists grasped experimental art's consolidation of the spectacle—according to the situationists, Godard's films represented a formal pseudo-critique that hindered authentic criticism of art and of the spectacle's splitting of life into specialized activities—and pointed to the way the commodity form in spectacular market capitalism had infiltrated all aspects of life.[7] They defined this spectacle as the anonymous totalitarian order of money, a depopulated world beyond human influence, the commodity world as representation process.

Reality, according to the situationists, had been turned into images beyond human control and any kind of dialogue had been replaced by the monologue of the image. Although it was the result of a complex social praxis, the image acted as an independent being. In accordance with the Marxist critique of capitalist society, which underpins the analysis, the situationists thought that capitalism's totalitarian need to individualize everything and privatize the collective resulted in a totally porous and disjointed society, which was only held together by permanent bombardment of slogans, brands and commercials.

The intensity with which we are all assaulted by images has not abated since the end of the 1960s, when Debord and the other situationists critically analyzed the society of the spectacle. What has happened, rather, is that the image machines produce faster and faster, to cover up a more and more threadbare sociality. Proof that society is falling apart is visible everywhere. The scaremongering images and commercials are meant to hide a standardized hollowed-out social texture, where the isolated and marketized individual is a slave of the fatuous offerings of the entertainment-fashion-information-technology system.

Returning to the narrower art-institutional dimensions of Western Marxism's critique of art, we must concede that the situationists' rejection of Godard's pseudo-criticism is also still pertinent. After all, the "political" exhibitions mentioned earlier clearly point to the discrepancy between the intended meaning of the exhibitions as in

some sense critical of the institution or system, and their function as legitimation of the existing. As Oliver Ressler explains, Taiwan's president Ma Ying-Jeou was, for example, very enthusiastic about the part of the Taipei biennial in 2008, "A World Where Many Worlds Fit", in which Oliver Ressler had curated about the alter-globalization movement and its anti-capitalist demonstrations. Any biennial with respect for itself, according the president, had to be "creative, energetic, sensitive and not least rebellious". The statement, of course, demonstrates the establishment's ability to subsume criticism while citing the existence of "criticism" as proof of plurality and openness.

This affirmative dimension is just as relevant today as it was during the Cold War, when the US staged modern art—Abstract Expressionism, for example—as an expression of the capitalist world's freedom (as opposed to the Soviet Union's propagandistic Social Realism). As Hal Foster diagnosed in "Against Pluralism", pluralism in contemporary art is very much to be regarded as a legitimation of an ostensibly liberated anything-goes relativism. In effect, this neutralizes critical approaches as an updated version of Marcuse's "repressive tolerance".[8]

Practicing the (im)possible

Let us try to shift perspective from art institution towards the praxis-oriented and take a closer look at some of the various approaches that have been used over the past 10 to 15 years in the critical, and therefore more interesting, part of contemporary art. One of the most prominent approaches has been so-called relational art, described by Nicolas Bourriaud as an attempt to *produce* new social conditions as a response to the destruction of human relations, which Bourriaud believes is taking place in late modern society. In the work of artists like Rirkrit Tiravanija, Philippe Parreno and Carsten Höller, Bourriaud found an intense interest in "interaction, co-existence and relational networks". For example, when Tiravanija "organizes a dinner at the house of an art collector, where he makes the necessary things available

with a view to cooking a Thai soup".[9]

In terms of art history, relational aesthetics was a way of reaching beyond the 1980s' critique of representation, which had originally taken the form of critical appropriations and displacements of mass media images. However, by the late 1980s it had ended up as shiny art objects that were indistinguishable from the commodities of the spectacular market society and the spin of the closed political public sphere. After the representation-critical art of the 1980s had been preoccupied with various postmodern theories of signs, text and simulation there was therefore a turn in the 1990s towards the performative. A movement away from representation and the (art) object towards transient and complex social interactions.

But as Hal Foster and Stewart Martin, among others, have written, relational aesthetics was characterized by a naive idea of presence and a greatly exaggerated faith in the space of art, which was assumed to constitute a socially harmonious enclave free of the disorder of the surrounding world.[10] Bourriaud went so far as to call contemporary art a space that was "protected from the uniformization of human behaviour". Relatively quickly, relational aesthetics and its non-committal types of relations therefore came to appear as nothing more than PR for the art institution and a small group of its most privileged agents. The vague sociality that was given form in relational works in no way challenged the institution, which had no trouble reducing apparently transitory relations to art objects, commodities and representations of sociality.

Another, more interesting tendency in contemporary art has been what one could call solution-oriented intervention art, which undertakes to propose solutions for complicated social and political problems, and to create new forms of collective social interaction. This art shares relational art's aversion to the representation-critical art of the 1980s since, to an even greater extent than relational art, it is productive, and proposes specific models for cooperation and ways of solving particular social problems. Artists like Kenneth A. Balfelt, Superflex, Wochenklausur or Asyl Dialog Tanken use artistic

imagination to visualize, debate and often even solve problems of a social and economic nature. For example, by giving Copenhagen's drug addicts the opportunity to fix in decent conditions, remedying prostitutes' lack of shelter in Zürich, the development of a biogas plant—which converts waste from humans and animals into gas, for the African market—and the establishment of a cultural centre and shelter for asylum seekers and immigrants in Copenhagen.

Instead of the avant-garde's antithetical approach to, and problematization of, artistic and political discourse, we have a pragmatic exchange between art and other spheres. The avant-garde's antagonistic relationship with the dominant political and economic actors like the state and multinational corporations is replaced by cooperation with a view to coming up with alternative solutions to concrete problems, inequalities and exclusions. Characteristically for this tendency, Superflex describe their art as "tools" and Balfelt refers to Charles Esche's idea of "Modest Proposals", where the artist, through his or her special approach, creates alternative modest proposals for solutions to concrete problems using artistic creativity and imagination.[11] The projects are thus decidedly constructive. The primary aim is not formal new departures or the exposure of suspect art-institutional circumstances; nor are they avant-garde transgressions. On the contrary, they are about using art (and public support for art) as a platform for constructive work outside the traditional space of the institution.

Undoubtedly, these are not only conscientious, but also in many ways particularly relevant efforts, which help to give visibility to neglected problems and to use the autonomy of art to address art-external issues. But in the light of Western Marxism's history of the transgressive potential of modern art, the projects risk appearing more administrative or pragmatic than critical.

This is very much a matter of compromising with the established system, of cooperating with it in the hope of repairing some of the damage it causes. But there is rarely any true criticism of the system; the causes of the problems are not exposed. So the risk, obviously, is

that this solution-oriented art collaborates with what already exists and in that way is situated within what Jacques Rancière calls the space of consensual politics, where there simply "is what there is".[12] Superflex's Guaraná project is an excellent example of this.[13]

Along with a group of Brazilian guarana farmers, who were under pressure from big multinational firms to lower the prices of their crops, Superflex developed and launched a soft drink, Guaraná Power, where a larger part of the profits than usual went to the farmers. The appealing soft-drink project is symptomatic of this type of art, which does not relate critically to the already-established structure, in this case capitalist commodity society and its market, which emerges as the unproblematized premise of the project. Superflex's statement seems to be that by developing a slightly left-field commodity with soft political connotations — "I drink politically" — and selling it on the market, the farmers will succeed in their project. Resistance is offered, but in a decidedly less than radical way. Instead of developing production and exchange models that are truly alternative, or criticizing the dependence and reification that capitalism causes, Superflex operates on the capitalist market as creative entrepreneurs recruiting new workers.

More relevant in this connection — where Western Marxism and the avant-garde are the prism through which we gaze at contemporary art — is the more negative or confrontational interventionist praxis that goes under names like semiotic terrorism, guerrilla communication or tactical media.[14] Loosely inspired by Dada's photomontages and the situationists' *détournement*, this is a matter of appropriating images or techniques and using them for other purposes.

In principle, these are not necessarily activities that have any direct connection with the art institution, but various kinds of activism; for example, anti-sweatshop campaigns, animal rights struggles and climate activism. In the 2000s, however, there has been wider exposure of this approach to the art institution, which would like to be associated with the authenticity represented by this praxis or tactic.[15] As Naomi Klein describes it in *No Logo*, the idea behind tactical

media is that large conglomerates and corporations will suffer most damage if their public image or visual identity is subjected to attack or manipulation.[16]

One example of such an attack is 0100101110101101.org's Nikeplatz of 2003, a homepage and a smart red information container on Karlsplatz in Vienna, which presented Nike's latest project. Here, the idea was to buy the square and rename it Nikeplatz, and place a large sculpture there in the form of the company's iconic Swoosh logo. The project was, of course, a comment on the ongoing neo-liberal wave of gentrification and privatization, where more and more areas of the city are going from public to private ownership, and where, for example, names of municipal and publicly owned sports stadia are sold to firms and private sponsors.

Another example of this type of art activism is the Yes Men, who have developed a praxis they call "Identity correction", where, by pretending to be representatives of public institutions like the World Trade Organization, they criticize them by exaggerating and caricaturing their policies, thus forcing the firms or institutions to relate publicly to problematical initiatives or unfortunate current cases. In 2002, for example, the Yes Men appeared as representatives of the WTO at a conference of accountants in Australia. Here, they announced that the organization would transform itself into the Trade Regulation Organization, the aim of which was to help people instead of capital. The hope is that by way of such false statements they can momentarily disturb or challenge the "naturalness" with which neo-liberal capitalism has been equipped since 1989. If this succeeds, the idea is that there can be a kind of spectacular disidentification with the omnipresent logos, whether they represent companies or politicians; also, that there may even be an opening, so that it becomes clear that things can look different. However, the question is whether this activism, in its use of the spectacular, will end up confirming the actual underlying representational system. Its dissidence is confined to minor corrections, which merely shows that society is open for criticism and odd, crackpot ideas. A kind of contemporary Michael

Moore of art.

As Matias Faldbakken has pointed out entertainingly and ruthlessly in his novels *The Cocka Hola Company* and *Macht und Rebel,* the tactical media approach is often threateningly close to merely advertising the companies whose images it distorts. This is because these companies are in many cases undoubtedly interested in being associated with an aura of "edge" and creativity, even illegality associated with such art practices.[17] The question is whether Nike's brand suffers any kind of serious damage or whether it is simply even more firmly encoded in the dulled, jaded brains of consumer subjects when 0100101110101101. org launches Nikeplatz and, for a brief moment, modifies Nike.

Across the significant differences between relational art, solution-oriented and negative interventionist art, it is clear that the practices mentioned earlier are characterized by a common aversion to overall strategies and overarching programmes in favour of an emphasis on the downscaled, the temporary and the tactical. There are undoubtedly reasons to look critically at the far-too-grand and radical project of the avant-garde, which staked all on wholesale transformation; but the question still arises as to whether or not there is anything at all left in contemporary art of the original resistance that it was supposed to embody.

These practices seem to suffer from the prevailing revisionist anti-communism and fear of revolution that has flourished more or less unchallenged since the state-capitalist party dictatorship in the Soviet Union collapsed. This equates more radical political and artistic projects with totalitarianism in favour of blind acceptance of the present wretchedness or very limited revisions of it.[18]

The art of the 1990s and 2000s has not challenged the narrowing of the political horizon that began with the postmodern upheavals of the 1980s. This was confirmed by the fall of the Wall in 1989, when the ideological struggle of the Cold War was replaced by a post-ideological scenario characterized by distrust of grand emancipatory narratives. In retrospect, it is clear that this emptying out of political discourse took place as a large-scale attempt to give neo-liberalism

hegemonic status. The (other) great political ideologies were shown the door in order to make the naturalization of the neo-liberal phase of capitalism seem natural. And the project succeeded to a great extent: from 1989 until 1999, neo-liberalism was, by and large, unchallenged and the least whiff of communism was dismissed as tending to the totalitarian.

The opening that the protests in Seattle, Prague, Genoa and other places seemed to make possible at the turn of the millennium was closed with great force by the established order through the installation of an anti-rebellion regime. This was dramatized after 9/11 as the war on terror, and is today legitimized by involving the combined threats of terrorism, immigration and climate change.

In retrospect, it is clear that relational aesthetics and intervention art, to varying extents, subscribed to this post-ideological discourse with their ideas of micro-utopias, specific proposals for solutions and ephemeral tactics that sustained no wider visions of a different future. The antagonisms of earlier times were superseded by limited efforts that set up temporary zones of free interaction in the space of art, or the mildly disturbed circulation of representations and commodities. General criticism of the current state of affairs appears to be a thing of the past.

But perhaps it is simply thoroughly uncontemporary to try to view contemporary art in the light of Western Marxism. Dispatches of bombastic reports to the dead can of course be dismissed as hopelessly caught up in modern, embarrassingly essentialist modes of thinking that are totally unable to grasp the present. It is quite conceivable that this is how things are. Why stress the impossibilities and point out the contradictions by referring to the grand defeats and shattered illusions of the past? Have we not moved on, and have we not put these crude and quixotic ways behind us, acquiring a more realistic approach to the possibilities, where we take our point of departure in the present?

At a time when revolutionary events first and foremost circulate as empty signs in the iconography of pop cultures, in which Baader/ Meinhof, Marx and Mao are fused together in an ugly blend that

sabotages rather than facilitates their memory, it is paradoxically precisely by insisting on the possibility of repetition and displacement that we can work towards a new departure. That we can create a potent nostalgia in Walter Benjamin's sense.[19] Perhaps it is not so bad, after all, to be at odds with the zeitgeist. Perhaps there is potential precisely here, in the anachronistic. Not that we should try today to play the role of Marx in 1848, Leviné in 1919 or Debord in 1968. The true upheaval is presumably always something that comes from the outside and appears incomprehensible to the established order.

Chapter 2

The Self-Murder of the Avant-Garde

"The whole root, all the exacerbations of our quarrel, turn on the word 'revolution.'"[1]
Antonin Artaud

Few phenomena tell us more about our present than the avant-garde and its fate. The absence or the presence of an avant-garde tells us something about a society, its history, its political culture and its idea of the future. In the destiny of the avant-garde, we can decipher what role art and politics play, and how these discourses are conceptualized and interact in a given period.

Within contemporary art there has been a lively debate about the avant-garde running for the last 20 years. These discussions have often been attempts to analyse the art that, since the early 1990s, has drawn on such precursors as conceptual art, performance art, Fluxus and situationism. This revival of interest in the art of the 1960s has led many to argue that contemporary art is a continuation of the neo-avant-garde as a kind of post-neo-avant-garde. Interest in the avant-garde has, of course, also produced many books on the interwar and post-war avant-garde. Unfortunately, most of these analyses seek to understand the revolutionary aspirations of the avant-garde in accordance with academic convention and are predominantly art historical.

If one does not analyse the revolutionary aspirations and self-understanding of the avant-garde, then its self-critical operations are reduced to a series of canonical works and formal experiments. The avant-garde was not merely artistic, but also had ambitions of social and political revolution; or, more precisely, the avant-garde was *not* specifically "artistic", insofar as the latter term is restricted to the predominant modern

conception of art as autonomous.

The avant-garde sought to confer the creativity of artists onto everyone, outside the confines of the art institution. In that sense, the avant-garde launched a radical critique of capitalist modernity's process of differentiation of and sought to end capitalist domination in favour of communism. The following argues for the necessity of the avant-garde's radical critique and presents some scattered remarks on its historical disappearance. It is primarily an attempt to question a number of certitudes concerning the avant-garde, in order to better answer why the avant-garde was so quickly caught up and superseded by the society it wanted to destroy. These remarks are thus both an attempt to free myself from the intoxicating universe of the avant-garde and an attempt to keep the energy of the avant-garde alive despite everything, especially the avant-garde itself.

The Disappearance of the Avant-Garde

Any definition of the avant-garde must start with its opposition to bourgeois society, with a view to formulating a cultural and political alternative to capitalism. The avant-garde not only scandalized the art institution with its "silly" objects and sneering acts, but it also intended to scandalize the bourgeois world in its entirety, including its edifying rationality and snobbish class distinctions. As an agent in the cultural process of bourgeois self-definition, the avant-garde strove to negate itself, and make humans alien to themselves and each other. It fiercely attacked both the residues of high culture of the aristocracy and the emerging "invisible" culture of the bourgeoisie, which was replacing former lines of alliance and power. This meant that the avant-garde not only attacked classical media like painting and sculpture, but it also attacked language and the image as such. It did this because the language and visuality that had "earlier" — it always turns out to be a retrospective construction — united people now separated them.

Capitalism had effected an expropriation of communicative and productive means, and now used them to reproduce an alienating and opaque world of work and consumption. In order to wrest humanity from the instrumental rationality of bourgeois society and supersede the alienating relations of capitalism, the avant-garde had to intensify alienation; only by making the world even stranger could the avant-garde get beyond that already existing, and make a truly modern and artificial world possible. Most of the time, this supersession was conceived within the framework of communism.

Few phenomena have had as dramatic an existence as the avant-garde. Despite the return of the avant-garde in discussions about contemporary art—the notion of the postmodern disappeared rather quickly—there seems to be a huge divide separating the art of today from the anti-art of the avant-garde. Projects like Wu Ming, Copenhagen Free University or Yes Men do not really come off looking like an avant-garde. Few artists today attempt to align themselves directly with political parties or revolutionary movements like the surrealists did in the 1920s and 1930s. This, of course, is not the fault of artists in any straightforward way, but has to do with the altered political context in which, in the West at least, there are no revolutionary political parties (that represent an alternative to the established system of capitalist democracy).

The connection between artistic experiment and political commitment that was so vital for the avant-garde is apparently no longer possible. Both the "artistic" avant-garde and the political vanguard have been swept away by a capitalism that has not only abolished former distinctions between high and low, but also integrated culture with capital and transformed politics into spectacle. The self-evident manner in which the surrealists reacted to contemporary events like the war in Morocco in 1925 to 26, where French forces led by Pétain crushed the Moroccan uprising for national liberation, were drastically reduced after

World War II, when groups like the Situationist International (SI) desperately tried to keep alive the project of the interwar avant-garde.

Since then, the "naturalness" of the avant-garde seems to have become historical and appears either implausible or unlikely today. The naturalness with which revolutionary art implied a revolutionary politics and vice versa rarely survived Stalinism, World War II and the emergence of consumer society. That's why Peter Bürger concluded that the post-war avant-garde reproduced the interwar avant-garde's attack on the art institution and bourgeois society primarily in terms of art.

While what Bürger (resigned in 1974, in the midst of the dissolution of the West German student opposition) termed the historical avant-garde connected its critique of art's institutional status with the struggle for another society, the post-war avant-garde merely thematized the art institution and showed critical gestures disconnected from any political projects or movements. As Bürger wrote: "The neo-avant-garde institutionalizes the avant-garde as art and thus negates genuinely avant-gardist intentions."[2]

Even though Bürger's rejection of the so-called neo-avant-garde was formulated on the basis of a problematic teleological conception of history, and even though his book does not account for the socio-historical conditions for the blocking of the avant-garde project, he nonetheless points to the profound transformation of the avant-garde during the 20th century.[3] Bürger was right in emphasizing the new situation that the neo-avant-garde faced in the 1950s and 1960s, where life was becoming much more organized than had been the case before.

After World War II, everyday life was literally colonized by commodities and the relative autonomy of art seemed to fuse with the production of the new objects. The second half of the 20th century is the story of how capital subsumed more and more aspects of human life. Not only commodities and tools,

but also the labour force was produced via the capital relation — the whole of society was productive/reproductive. Jacques Camatte describes this as the capitalization of human needs, where people become capitalist creatures desiring their own submission (through the remuneration of work).

> Now it is not only the proletarians — those who produce surplus-value — who are subsumed under capital, but all men, the greater part of whom is proletarianized. It is the real domination over society, a domination in which all men become the slaves of capital [...]. Thus it is no longer merely labor, a defined and particular moment of human activity that is subsumed and incorporated into capital, but the whole life process of man.[4]

Already in the 1940s Theodor Adorno and Max Horkheimer described how this development effected art.[5] The value form tended to absorb all art forms and remove its subversive exterior, where the artist could experiment and from where the artist mobilized critique. This development not only transformed the relations and forces of the production of art, but it also changed politics in a way the established Left was unable to understand. This resulted in a situation where large parts of the Left remained attached to an unproductive historical materialism, and its categories of class and historical development.[6]

In the immediate post-war period, art was squeezed into the reductive oppositions of the Cold War, where two seemingly incompatible logics — the Western nation state system, with its parliamentary democracy and individual freedom on the one side, and the state-communist collectivized economy and party apparatus on the other — effectively derailed any attempt to connect artistic experiment with communism. Even though the direct link to former avant-garde experiments was cut, and artists therefore had to make do with a random genealogy, the

31

SI succeeded in rising to the occasion, and rejoined the link between artistic experiment and political commitment. This was, however, the exception that proved the rule.

The small situationist group was radically opposed to the developments taking place in the post-war period, perceiving it as a new counter-revolutionary phase in the development of capitalism, and sought to abandon art in favour of a revolutionary practice. Their "totalistic", heroic, grandiose solution, in which the situationists risked it all and ended up without art, in many ways marks the culmination and end of the history of the avant-garde.[7] The SI pushed the avant-garde claim about being at the forefront of their time to an extreme point, demanding the impossible of its members, who were not to behave in a counter-revolutionary manner in everyday life: there was not supposed to be any separation between private behaviour and the communist critique of political economy.

As the domination of the society of the spectacle grew, the situationists tried to disconnect themselves from art in order to save the avant-garde position. The costs of this rescue operation were massive: the situationists' theses were not only able to point to the new forms of social control, but they were also abstract and bombastic, founded as they were on the primacy of concepts like separation, alienation and spectacle. The situationist critique was reductively and endlessly repeated, and nobody and nothing was safe from it, bringing with it an air of paranoia and complacency. Other contemporary artists, such as those associated with Fluxus or conceptual art, opted for a more "realistic" move and settled for less than the situationists' all-or-nothing challenge.

Conceptual art and other contemporary art practices did not recreate the earlier avant-garde's direct link between the artistic and political avant-garde, but instead tried to keep artistic experimentation alive. The expansion of the concept of art was the result of this strategy, which was, from the point

of view of the avant-garde, unambitiously satisfied with limited and "suspect" aesthetic gains. From a postmodern perspective, however, the expansion of the concept of art made possible a continuous process of inquiry, where art should no longer seek to destroy or create the world anew.

The idea of the avant-garde played a limited role in this process of expansion: artistic practice and political reflection was not united in one text but was kept separate. The avant-garde synthesis of artwork and world was replaced with more moderate approaches which, on the one hand, continue the radical and coherent critique the avant-gardist wager. On the other hand, it does not degenerate into megalomania and redundant stylistics (which the avant-garde's syntheses often tended to).

Although we should avoid simple periodization, it seems fair to say that the conditions of possibility of the avant-garde more or less disappeared after World War II. The old agrarian elites and their cultural forms were swept away with the War, leaving the bourgeoisie and the avant-garde without aristocratic high culture to appropriate and ridicule. At the same time, the political horizon was effectively closed, with the appearance of stable democracies in Western Europe and bureaucratic communism in the East.

The industrial and technological developments of the War were subsequently used to implement a standardized mass culture, where technology lost its former visionary significance for artists and became part of everyday life, creating a culture that was organized around symbolic production and consumption. As Perry Anderson argues, no matter how artists reacted to this development, their art was to a large extent destined for commercial integration or institutional co-option.[8] We can see this in the desperation and paranoia of anti-art groups like the situationists.

Of course, the idea and perspective of the avant-garde did

not disappear overnight, but survived in different guises and equipped later art with an overdeveloped institutional awareness. If one follows Bürger's definition of the avant-garde as the combination of an attack on the institution of art with a utopian project of communist revolution, the SI appears as one of the few examples of a post-war avant-garde.

None of the American or West European artistic practices like minimalism, pop art or even Fluxus had such aspirations. Even the most politicized conceptual art, like that of Art & Language— including the group that gathered around the publication *The Fox* in New York or the interventive plasticity of Artist Placement Group—nevertheless still made art in a very different way than the situationists.[9]

That the situationists remained attached to a certain understanding of art—according to which art possesses a potential in a divided capitalist world (but only insofar as art is no longer art but integrated in a revolutionized everyday life)— is another matter. The situationists did not intend their actions to be understood as art and did everything to prevent them from circulating as such. It therefore seems advisable to follow Bürger's distinction between a historical avant-garde and a later neo-avant-garde, regardless of whether the latter manifested itself as situationist, or as pop or conceptual art, without the situationists' revolutionary pretentions.

Although Bürger's distinction between avant-garde and neo-avant-garde remains relevant today, the situationists' forced attempt to continue, and radicalize, the project of the historical avant-garde after World War II, and the full-scale introduction of a spectacular commodity society, testifies to the rapid disappearance of the avant-garde. The connection between the will to intervene in social reality and the realization of (im)material textuality was loosened at this time, and has remained so ever since.

The history of the disappearance of the avant-garde has to do

with the disappearance of a revolutionary perspective and the closing down of a radical horizon. Whether or not the ongoing collapse of the global economy is the end of the neo-liberal cycle of accumulation, or indeed might turn out to present the possibility of an exit from capitalism altogether, remains a matter of debate. The presumption of an end to neo-liberalism relates directly to the conditions of possibility for the constitution of the avant-garde.

The avant-garde position has not been available for quite some time, but that might be changing. The disappearance of the avant-garde was both a possibility and a serious problem: a problem because the radical critique of the avant-garde is necessary if we do not want to settle for minor changes and a possibility because the avant-garde's self-understanding always maintained a pretence of knowing what is to be done.

The avant-garde looked upon itself as at the centre of radical change, as if its products and acts were revolutionary in themselves. Although the opposition of the avant-garde has still to be made available—*it is still necessary to create disorder and break the movements of homogenization*—this has to be done without reducing the mass to a placid body that needs to be organized. This is the impossible heritage that the avant-garde has left us with.

The Self-Production and Self-Destruction of the Avant-Garde

On 15 March 1963, Guy Debord wrote a letter to the sociologist Robert Estivals in response to the latter's new book, *L'Avant-garde culturelle parisienne depuis 1945*. Debord felt it necessary to correct Estivals, and account for the true understanding and use of the concept of the avant-garde. According to Debord, Estivals, who had been a member of the Lettrist group that Debord broke away from in 1954, had not only misrepresented, but also completely misunderstood the concept of the avant-garde.

Estivals' 1962 book was also deemed by Debord to suffer from the fact that it tried to take a historical approach to the question and therefore had not included an account of the transformation that the SI had been carrying out since the late 1950s. Estivals' analysis was therefore merely retrospective, and his book had no value for the present and future work that the avant-garde was to undertake. Debord was thus compelled to explain matters to Estivals under the provocative heading "The avant-garde in 1963 and after".

The sociologist had understood absolutely nothing. According to Debord, being avant-garde meant not only being conscious of and affirmative towards the new, but also dedicated to realizing it in the present. Insofar as the present was an inauthentic present, in the sense of being characterized by past representations and ideas of the avant-garde, one should fight against the present in the present and for the sake of the future. As Debord put it: "The avant-garde... describes *and begins* a possible present, which its historic consequences will confirm in the ensemble by the most extensive realization."[10]

Debord continued his instructions to Estivals, explaining that the term avant-garde could be used in both a strong and a weak way. While the weak use of the term was a description of progress in a general way, applicable to progress within medical science, industry and art alike, the strong notion of avant-garde described an overcoming of the social totality, an alternative organization of reality. According to Debord, the avant-garde in the strong sense of the term was not only preoccupied with parts of life, but also addressed all of society, the social totality.

Historical development had shown that only a total and all-encompassing critique of society was capable of challenging its recuperation by the present order, which had no problem accepting piecemeal criticism as long as it did not attack it as a whole. Limited criticism was even welcomed, Debord argued, as the ruling order seeks to appear tolerant and inclusive. Because

of this situation, where any avant-garde who did not reject capitalism in its entirety was complicit in the maintenance of existing society of alienation and separation, the strong avant-garde had left behind the limited sphere of art and had, in one and the same movement, joined and transcended the political avant-garde. The strong avant-garde no longer created artworks; instead, its primary activity was its self-creation. Such an undertaking, Debord argued, was not only of utmost importance, but also an extremely risky business, insofar as capitalist society does everything to prevent a genuine avant-garde from being created.

Debord ended his four-page letter to Estivals with a warning. As a sociologist, Estivals could try to judge the avant-garde, but his judgment was of no value whatsoever. On the contrary, Debord argued, the judgment of the avant-garde was what counted, as the avant-garde was the present seen from the future. "If it really is an avant-garde, it carries in itself the victory *of its criteria of judgment* against the era (that is to say, against official values, because the avant-garde exactly represents this era from the point of view of the history that will follow it)."[11] For Debord, then, trying to analyze the avant-garde sociologically is an absurd undertaking.

While it is possible to map the weak, or false, avant-garde sociologically and to account for the historical conditions for the disappearance of the real avant-garde, it is a contradiction in terms to try to analyze the current strong avant-garde. Only by accepting and adopting the vocabulary of the avant-garde is it possible to understand it. Only by entering into the language of the avant-garde can sociology get up to speed. In case Estivals was still somehow uncertain about the meaning of Debord's letter, he ended it by writing that only by accepting and using the theories of the SI was it possible to understand what avant-garde meant today.

Debord's letter to Estivals tells us a good deal about avant-

garde self-understanding. Primarily, the letter shows us that the avant-garde is a special gesture that takes the form of a command. The avant-garde demands to be dealt with in a particular way. Estivals cannot just write about the SI as if he were writing about any other art group. If Estivals is to avoid being ditched by the acceleration of history, he has to submit to the claims made by the SI. As Tiqqun wrote, you can only write or talk about the avant-garde *as* an avant-garde and from within its ranks.[12] The avant-garde can only be experienced from within. Defining the avant-garde means analyzing and coming to terms with this particular self-expropriation. The avant-garde absorbs itself. The avant-garde sequesters itself. That's why texts and articles about the avant-garde always appear supplemental. At best, speculation adds to the avant-garde's own analyses and interventions.

As Paul Mann writes, the books and texts about the avant-garde that keep piling up are nothing but histories about a history—the avant-garde has always already made itself into a discourse, and the articles and books only articulate the passing of avant-garde discourse.[13] The avant-garde is thus a particularly paranoid subjectivization that overwhelms everyone who comes into contact with it, resulting in a kind of vertigo that makes it impossible to remain neutral and detached.

The avant-garde sees itself as the highest expression of revolutionary consciousness. As *the* revolution or *the* enemy, as Percy Wyndham Lewis termed himself and one of his many one-man journals, the avant-garde is the one who denounces the hypocrisy of the world and negates all established authorities— not just the enemy of this or that, but also the enemy *tout court*. The sociologist cannot analyze the avant-garde, since the avant-garde has already staged itself as the revolution, the exception or the enemy.

As is evident from Debord's letter, the avant-garde has a complex relationship with the outside and especially with the

masses. The avant-garde looks with equal contempt and envy at the mass, which incredibly seems to be somehow at ease with itself. This is a complete scandal in the eyes of the avant-garde according to whom the world must be transformed. Only a complete break with the existing world matters. Only through an all-encompassing transformation is it possible to smash capitalism's empire of passivity and make a true life possible. The indifference of the masses, the scale of its apathy and the joy the uninitiated nevertheless express enrages the avant-garde, and confirms its outright dismissal of the masses and its reality.

As was evident with Debord and the situationists, the avant-garde never tires of authoritatively condemning the spectacle as false and goes so far as describing itself as God.[14] With this division of the world into outside and inside—the ones who are in on it and the ones who are idiots—the avant-garde reproduces the gang structure which, according to Jacques Camatte and Gianni Collu, characterizes all organizations in a capitalist society. Because of the enormous pressure that all freely or unfreely marginalized individuals experience in capitalist society, the individual seeks refuge in the gang. Vulnerability, and fear of violence and loneliness, forces individuals into a gang, where they enter into a hierarchy, which because of its rigid strictness promises another social structure.

> To belong in order to exclude, that is the internal dynamic of the gang; which is founded on an opposition, admitted or not, between the exterior and the interior of the group. Even an informal group deteriorates into a political racket, the classic case of theory becoming ideology. [...] The interior-exterior opposition and the gang structure develop the spirit of competition to the maximum. Given the differences of theoretical knowledge among the members, the acquisition of theory becomes, in effect, an element of political natural selection, a euphemism for division of labor. While one

is, on the one hand, theorizing about existing society, on the other, within the group, under the pretext of negating it, an unbridled emulation is introduced that ends up in a hierarchization even more extreme than in society-at-large; especially as the interior-exterior opposition is reproduced internally in the division between the center of the gang and the mass of militants. The political gang attains its perfection in those groups that claim to want to supersede existing social forms.[15]

The avant-garde reproduces this division, upholding discipline with the threat of exclusion: everybody who does not respect the norms of the gang is separated and exposed to slander, thrown outside to the violence and misery of the external. As Cammate and Collu write: "What maintains an apparent unity in the bosom of the gang is the threat of exclusion. Those who do not respect the norms are rejected with calumny; and even if they quit, the effect is the same. This threat also serves as psychological blackmail for those who remain."[16]

The avant-garde is divided between the present condition of the world and the state towards which the avant-garde wishes to direct the mass. The avant-garde is divided between what is and what ought to be. In this limbo the avant-garde tumbles around, destroying itself in the search for the avant-garde position. Its grandiose actions, violent exclusions and spectacular breaks are all signposts on the avant-garde road to dissolution. As Tiqqun wrote:

The avant-gardes spin in place in the self-ignorance that consumes them. And at last they collapse, before ever really being born, without ever really managing even to get started. And that's the answer to the most naïve question about the avant-gardes, which asks what exactly it is that they're the avant-garde of, what it is they're heralding: the avant-gardes

are above all the heralds of themselves alone — chasing after themselves.[17]

The avant-garde is an almost born dead project, exploding before it gives birth to anything at all, as it is suspended in an infinite projection of itself beyond itself. It turns and turns in the excited chase of itself, and crashes without ever realizing its grandiose plans, as was the case of the SI, which collapsed after May 1968 in a mixture of expectations of a coming victory and paranoia. After the students had left their libidinal energies to roam in the streets of Paris and the workers had left the factories, the situationists were sure that they were living through "the beginning of an epoch".[18] Imagination, however, never really took power, and the Grenelle negotiations replaced the dissatisfaction and unrest with higher wages and fewer restrictions for students.

The situationists wrestled with this development in the years between 1968 and 1971, trying to distance themselves from the growing milieu of supporters who threatened to blur the distinction between integrated and outsider. This was unacceptable and one by one or in bundles, members were expelled until only three members were present: Debord in Paris, Sanguinetti in Italy and, forgotten by everybody including his situationist friends, J.V. Martin in Denmark. At that time there was nothing left to do but dissolve the organization.

The Orders of the Avant-Garde

The document Report on the Construction of Situations and on the International Situationist Tendency's Conditions of Organization and Action, which Debord presented at the founding meeting of the SI in Cosio d'Arroscia in July 1957, begins with the sentence: "First, we believe the world must be changed."[19] Debord could not have chosen a better way to begin a manifesto for a new avant-garde, since the subjectivization of the avant-garde always takes the shape of orders or commands — "the world must be

changed". The order is the enunciation for which the avant-garde is the subject. "Transform the world", "change life" and "construct situations" are the most reproduced imperatives of the avant-garde over the course of the 20th century.

Debord naturally continued his manifesto by stressing the radical nature of the change the SI was striving for: "We desire the most liberatory possible change of the society and the life in which we find ourselves confined."[20] Debord wanted nothing less than complete transformation. He continued by explaining that the socio-material conditions for such a transformation were present, but were blocked by the capitalist system, which had created a world dominated by the commodity.

But the situationists had a vision of the future society, of the abolition of prehistory and the realization of communist society. The present was characterized by an idolatrous life, in which images had replaced God. Mass media, journalism, politics and commercials had fused in a separate image world that the avant-garde had to destroy. The dominance of capital was becoming complete thanks to the production and consumption of material and symbolic commodities that were all images. These images that held together a divided society were to be rejected. This was the task of the avant-garde.

Just as the surrealists did not manage to liberate the unconscious, the situationists never really succeeded in transforming the world or re-establishing the revolutionary tradition. In fact, nobody has been able to transform the world, change life and construct situations as completely as the sworn enemy of the avant-garde, namely capitalism. Capitalism does not loudly proclaim anything, but it continuously revolutionizes the world. As Camatte writes: "In the era of real domination, capital has run away [...], it has escaped."[21]

Manfredo Tafuri makes a bold assertion when he argues that the avant-garde has actually done the job of capitalism insofar as it intensified the alienation of capitalist value production.[22]

Its aversion to the old world was so intense that the avant-garde threw itself into the arms of capital and helped it to empty humanity, making the individual fragile and thus more receptive to the representations of the market.

According to Tafuri, the project of the avant-garde was a success insofar as it managed to internalize modern shock. The world was indeed transformed, but not in the way the avant-garde wanted. The unconscious and the imagination was indeed let loose, but as part of a permanent entertainment spectacle from which there is no escape and where image commodities are quickly replaced by new ones in an endless movement. Capital constantly transforms the world, changes the every day and constructs situations.

After the avant-garde has prepared the terrain and emptied the subject of any kind of sense of community, a capitalist economy moves in and fills it with images, slogans, logos and jingles, thereby maintaining a sufficient level of consumption. Thanks to the montages and assemblages of the avant-garde, the money economy is victorious to such a degree that it no longer looks upon the world as the outcome of a long history, but as the primitive looks upon the forest—as its natural environment. This is the tragic destiny of the avant-garde according to Tafuri: it carries out the work of capitalism.

There is an unconscious connection between the avant-garde and capitalism, which means that the avant-garde at one and the same time sublimates and affirms the levelling movement of capitalism. With its actions, manifestos and buildings, the avant-garde desensitizes humanity, intensifies alienation and thereby prepares the way for capitalist colonization.

In the swarm of the city the avant-garde not only struggles against the destruction of experience, but it also ends up naturalizing alienation, programming humanity for a new type of behaviour. It is as if the injunctions and orders of the avant-garde inhibit their realization: they stun more than they activate.

It does not make sense to order someone to attack capitalism. It cannot be anybody's duty to abolish wage labour. This is something one does for oneself together with others and not on behalf of someone else. But the avant-garde never tires of commanding the mass to change the world, life and itself. The avant-garde demands the mass to take over something it already lives and moves within.

As we know from the many accounts of the avant-garde, one of its central categories is the "new". The avant-garde is in accordance with its original military meaning as a vanguard that moves where the rest of the army will follow. The avant-garde is, as Tafuri writes, "seeking complete domination over the future".[23] The avant-garde's "new", however, does not exist but is radically exterior to society. The "new" is the total destruction of everything that is not empty, a destruction of all the old stuff. The avant-garde is thus without an object and strives to destroy everything, leaving nothing but ruins in its wake.

For the avant-garde, it is of utmost importance to prevent the "new" from becoming comprehensible. If this happens—if the meaning of the "new" is suddenly fixed—the "new" is no longer the "new" but merely part of the already existing, part of the old world; the "new" would be recuperated, integrated into the established taste. According to this logic, the "new" cannot have an object. The practice of the avant-garde is thus a continual emptying of the "new", a making meaningless. The avant-garde has to make sure that the "new" remains an exterior threat to the signification system of society.

Ultimately, the avant-garde is the total destruction of all traditions, laws and symbols, as was the case with Sergey Nechayev, the most radical exponent of the emptying of the "new" in the 19th century. For Nechayev, everything was permitted in the attempt to create empty forms. His avant-garde would destroy and negate everything; nothing was to be saved in the battle against the existing world.[24] Even though

44

most avant-garde groups refrained from political violence in the battle against the society of the spectacle, violent emptying is a permanent ingredient in the avant-garde's repertoire and offshoots.

The Missing Body of the Avant-Garde

For almost a decade the surrealist group struggled to unite the "artistic" avant-garde—the surrealist group itself—and the political avant-garde in the shape of communism. In the middle of the 1930s, however, those surrealists who were led by André Breton came to a definitive break with the French Communist Party. The surrealists had tried their best, but had to pull back and manifest their disapproval of the increasing Stalinization of the Party.[25]

The political awakening of the surrealists took place in 1925, when Breton and other members of the group realized that the transformation of life they wanted also required a transformation of society's socio-material conditions. After a series of breaks and fights both within the surrealist group and with other para-communist groups, Breton managed to turn surrealism towards the French Communist Party. According to Breton, this Party was the most important representative of a radical critique of the French parliamentary system and the bourgeois life that the surrealists wanted to overcome. Despite setbacks in the Soviet Union, the Communist Party still appeared as the most revolutionary actor, as it incarnated the heroic events of 1917 in Russia.

In retrospect, it is evident that the surrealists were caught in the paradox of the October Revolution. On the one hand, the Russian Revolution changed world history by giving socialist revolutions the world over a territorial base in the Soviet Union. On the other hand, the failed revolutions in Western Europe forced the Soviet Union into a terrible cycle of "primitive socialist accumulation". Over a long period, the future expansion of

socialist revolution was dependent upon material and political support from a Soviet Union that at the same time, because of the quick consolidation of bureaucratic despotism, became a virtual dystopia for the Western working class and an obstruction to the creation of internationalism. The paradoxical consequence of the October Revolution was thus a "provincialization" of the European working class and the bureaucratic devaluation of socialism in the Soviet Union.

The connection between political theory and the organized labour movement was cut in the 1920s and 1930s, and it remains very debatable whether or not the Soviet Union was a threat against the kingdom of capitalism after 1924. The surrealists believed so for almost a decade, but they changed their minds as Stalin made every effort to detach the Soviet Union from the dynamic of permanent revolution in the period from 1935 to 1947. Instead, it tried to reclaim Russia's old position as a legitimate power with a traditional sphere of influence.

It took several years before the surrealists came to the realization that the French Communist Party was in effect a hindrance to the establishment of a revolution. At the end of the 1920s, the surrealists enrolled in the Communist Party in order to give the surrealist revolution a political perspective. The internal polemics of the surrealist group were apparently over and done with, and Breton and the remaining members concentrated on uniting political action with surrealist activity: surrealism in the service of the revolution.

The Communist Party was, however, anything but excited about the surrealists' reapprochement, and there was constant tension between the surrealists' quest for spiritual emancipation and the Communist Party's wish for a socio-material overhaul of capitalism.[26] Despite the fact that the surrealists were quite subdued in their criticism of the Communist Party, the rapprochement never really took place, because the Party advocated a rigid materialist conception of reality that in the long

run was incompatible with surrealist interest in the anarchic, the seemingly meaningless, the absurd and the random.[27]

As the Communist Party slowly but steadily abandoned or toned down its revolutionary rhetoric, blocked out any kind of internal opposition (as with Boris Souvarine and Pierre Monatte) and tried to legitimize the developments in the Soviet Union, where party dictatorship and state capitalism went hand in hand, the contradictions between the surrealists and the Communist Party grew. The surrealists continued to mock the nation, the family, bourgeois morals and work, and in 1933 Breton, Paul Éluard and René Crevel were excluded from the Party. That did not mean that the surrealists stopped attempting to unite surrealism and communism, which was, by now, a mixture of Stalin's and Trotsky's theories. But it did not take long before the adventure ended.

In 1935, Stalin and the French Foreign Minister Pierre Laval signed a treaty of mutual assistance between France and the Soviet Union, thereby encircling Nazi Germany. This was a huge event, as the Soviet Union adopted a Western-oriented foreign policy and finally confirmed the abandonment of the strategy of permanent world revolution that Lenin advocated until his death.[28]

Until 1935, policy in the Soviet Union and the different national communist parties, including the French, had been based in Lenin's campaign against World War I, arguing that war between capitalist states was an imperialist war that should be transformed into revolution. With this treaty, Stalin dissolved the revolutionary internationalist perspective and made it possible for the communist parties to support national defence and alliance with non-revolutionary leftist parties. This effectively abandoned revolutionary communist aspirations to overthrow bourgeois democracy.

The surrealists reacted strongly to this nationalist turn and in June, during the International Congress of Writers for the

Defense of Culture, the surrealists finally bid farewell to the French Communist Party.[29] Breton did not attend, as he had been involved in a scuffle with the organizer of the congress, Ilya Ehrenburg. But Éluard gave a speech, where he strongly criticized the treaty between France and the Soviet Union, and mocked the idea of nation states. This speech, which in many respects marked the end of the alliance between the artistic and political avant-garde, ended with the legendary words: "Transform the world, said Marx, change life, said Rimbaud, these two watchwords are one for us."[30]

The French Communist Party did not make room for Breton and the surrealists. In the Soviet Union, the Bolshevik party was only briefly interested in letting the "artistic" avant-garde participate in the revolutionary process. The fate of the Soviet avant-garde is witness to that fact. As Boris Groys has written, there was no need for two avant-gardes in the Soviet Union after 1917. The political avant-garde, in the form of the Bolshevik party, was just as engaged in aesthetic concerns as the "artistic" avant-garde was in engaged politics and so the party considered the artists to be competitors.[31] While the "artistic" avant-garde is always trying to fuse art and politics from the point of view of art, the political avant-garde is involved in a symbolic practice conceptualizing politics as a kind of art.

Politics is a kind of fiction where a community is given form in an active sense when it is represented. As Groys argues, the Communist Party was well aware of that and did not want any competition. The vanguard was the party; only the party could direct the revolution and lead the masses. Only the party was capable of directing class struggle in accordance with the Marxist history of science. Lenin had already made that clear in 1902 in *What Is to Be Done?* and stressed it again after 1917. The party was to be a revolutionary vanguard, the general staff of the proletariat organized as a closed and strong centralized cadre.

The spontaneous action of the masses was not enough.

The party had to intervene and guide the struggle. The party intervened on behalf of the masses. Loyalty, and what Lenin described as iron discipline, were the key words for the avant-garde organization, where only the most schooled and disciplined had a place. The mission of the avant-garde party was to inject socialist consciousness into the masses. Lenin considered the working class a passive object that the party should steer, and form into the proletariat, the historical subject capable of destroying capitalism. The party was thus the subject whose intervention was absolutely necessary. As always with the avant-garde, subject and object were separate, and the party was to shape and form an object it did not consider itself part of.

We find a version of this idea of the lower classes' lack of intelligence and the need for external steering by an all-knowing avant-garde in Marx. Although he considered the Communist Party as the organization of an objective movement bringing society towards communism, and although he did not operate with a notion of a "socialist consciousness" to be imposed on the masses from without, as Lenin did, Marx nonetheless reproduces, at times, the avant-garde's self-privileging.

Disappointed with the failures of the 1848 revolutions, Marx gave up on the actual workers in favour of the theoretical concept of the proletariat.[32] The proletariat thus became a normative category with which the Marxist scientist monitored and compared the actual workers, in order to see whether or not they deviated from the revolutionary project. Marx's impatience with the workers in Paris—they were behaving foolishly—was transformed into a science where the workers were rejected as petty bourgeois if they did not live up to the concept of the proletariat.

In conflict with emancipatory aspirations, Marx in effect shut the disempowered up in their lack and assigned himself the role of the knowing teacher, the avant-garde, the head of the ignorant mass. As Jacques Ranciére sums up Marx's formula: "People

'make' history but they 'do not know' they do so."[33] When class struggle reached its final phase and tore capitalist society apart, a small part from the dominant class — "the bourgeois ideologists, who have raised themselves to the level of comprehending theoretically the historical movement as a whole" — stepped down into the mass and guided it.[34]

The political task, for Marx, was to make sure that history developed as it was supposed to. But history did not develop according to Marx's plan; where the proletariat was supposed to have appeared, Marx saw comic and contradictory figures. The problem was that the workers wanted to be satisfied here and now, and so appropriated petty bourgeois conceptions of happiness and solidarity, instead of becoming the negation that Marx and his theory of the revolution had predicted.

The problem was that the workers behaved as if they were already free. The workers confused means and ends, and created a "wrong" and "all too easy communism". Marx was forced to dismiss these mistakes and wait.

> It is too hard a task, even for the best dialecticians, to prove to communist proletarians that they are not communist proletarians by invoking a communist proletariat whose only fault is that it does not yet exist. [...] The only thing to do is to leave things alone [...] and wait for the coming communist proletariat and its organized movement.[35]

Marx strangely negated and affirmed the stupidity of the working class, and staged himself as the knowing subject able not only to decipher, but also predict the movement of history. He thus moved towards the working class, glorifying the historical role of the proletariat, but only after having separated himself from it. The bourgeois ideologist was somehow the brain of the proletariat, waiting for it to manifest itself in accordance with the bourgeois ideologist's theory of history.

While Marx waited for a proletariat that had not yet manifested itself, Lenin did not wait; he was impatient and mobilized the miniscule Russian working class, trying to accelerate the revolutionary process. He knew what was to be done: leadership of the party and hierarchy of the organization. Only by being guided by the party, which knows the direction of history, will the mass of workers manage to organize itself and revolt. On their own, the workers are reformist; it is the revolutionary avant-garde party that knows how to get things rolling.

Lenin, the French Communist Party, the surrealists and the situationists were all trying to give shape to the formless and ignorant mass. Even though "artistic" avant-gardes like the situationists were dismissive of the centralism of the Communist Party and rightly rejected it as nothing but a capitalist institution fighting other capitalist groups over state power, they nonetheless remained dependent upon a similar notion of the all-knowing avant-garde. The situationists praised the anti-bureaucratic tendencies of the revolutionary movement that Lenin and later Stalin persecuted, but they did not manage to break away from an elitist avant-garde model and its inherent centralism. They almost ended up looking like a farcical small-scale version of the Third International, with a central committee, ukases and exclusions.

Beyond the Avant-Garde

Even though we are in the midst of a dynamic historical situation, where the imperial hegemony of the US is tottering and the world economy is in crisis—a situation not unlike the period from 1914 to 1945, where two large-scale wars were necessary in order to arrive at an adequate rate of profit for new capitalist expansion—we have not yet seen the reappearance of an avant-garde like surrealism or the SI. But with the revolts in North Africa and the Middle East we have a revolutionary challenge to the present postcolonial world system with its extreme

inequality, and division of the world into zones of extreme poverty and fortified wealth.

It may, therefore, be a question of time before we see the re-emergence of something like the interwar avant-garde. Time will tell. There is no question that there is a need for the avant-garde's radical critique. So much needs to be destroyed. The question, of course, is whether or not *everything* has to be rejected and destroyed.

Although the extreme claims of the avant-garde and its militant criticism of the existing world is desperately needed, it is perhaps no longer necessary to create the world *ex nihilo*. The insistence of the avant-garde on totality, its narcissism, and its abstract and blank denunciations, needs to be critiqued. Perhaps we can finally replace the avant-garde's pure rejection by an affirmative critique of the existing—a critique that does not demand humankind to embrace "life", "the situation" or "the community" because they are always already thrown into it. Perhaps it is possible to critique the domination of capital with an awareness of the danger inherent in the desire for revolution and another world. As Jean-Luc Nancy writes, what we are left with today is a double demand, according to which we have to create a world where everything is not already done, nor still entirely to do.[36]

Chapter 3

After Credit, Winter: "The Progressive Art Institution" and the Crisis

The global economy is collapsing and it seems as if we are heading towards the finale of the present financial regime. Whether or not it really is a "terminal crisis" in Giovanni Arrighi's sense—the end of a cycle of accumulation—remains to be seen, but the accelerated pace of the crisis from the mortgage default rate tilting sharply upwards in 2006 to the financial crash in 2008 and onwards, points inevitably in that direction.[1] This might turn out to be the end of the American empire Arrighi had already prophesized in 1994 in his acclaimed *The Long Twentieth Century*, where he showed how capitalism has had four systemic cycles of accumulation since the 14th century. Each cycle with its own imperial leader—a Genoese cycle, from the 15th to the early 17th century; a Dutch cycle, from the late 16th through most of the 18th century; a British cycle from the late 18th century to the early 20th century; and a US cycle, which began in the late 19th century—ruling for about 100 years, or a little more, going through three phrases before collapsing and making space for the next cycle. According to Arrighi, each systemic cycle is characterized by the same phases, from an initial one of financial expansion, through a phase of material expansion, to another financial expansion.

The upwards trajectory of each hegemon is based on the expansion of production and trade. At a point in each cycle, however, a crisis occurs as a result of the over-accumulation of capital. As Arrighi describes it, financial expansion announces the autumn of a particular hegemonic system and precedes a shift to a new hegemon. Arrighi is thus able to show how the financial expansion of the last decades of the 20th century was

not a new phenomenon but a recurrent historical tendency of capitalism.

With the so-called financial crisis, it seems as if autumn is being replaced by winter.[2] Whether this crisis really is the end of a cycle of accumulation, no one knows, but all the financial expansions that have taken place since the early 1970s are fundamentally unsustainable, as they have been drawing more capital into speculation than can be managed. Now, the bubbles have begun bursting, signalling a possible end of a regime of accumulation. Terminal crisis? Time will tell. But we already have a pretty good first impression of the next phase of the end as austerity takes on the characteristics of a global political regime in which governments all over the world, in an even more visible and brutal manner than for the last 35 years of neo-liberal rule, impose austerity in the form of lower wages, lay-offs of public workers, passing legislation weakening organized labour and making cuts in programmes benefiting working people.[3]

Here we are now. Crisis and breakdown. It is an open question what will happen and what the next cycle of accumulation will look like. It will take some time and the disproportions of the current cycle will most likely have to be resolved by crisis, shakeout and probably also a major war, not unlike the last transition from UK hegemony to US. But an exit from the capitalist system altogether and the destruction of value is also becoming a possibility. This is the revolutionary perspective that is being advanced by parts of the revolting masses in North Africa and the Middle East, and picked up by the young protesters in Spain, Greece, the US and elsewhere. A critique of the capitalist money economy and the present neo-liberal world order, and its extreme inequality locally as well as globally.

Moving from these large-scale historical global events and the political economic phantasmatic level of world history, to a consideration of developments in contemporary art, and in particular the workings of so-called progressive art institutions

in Western Europe and the US, is not straightforward. There is a question of scale here. Nonetheless, it is interesting to consider a couple of recent events in light of the current conjuncture of crash, crisis and austerity—events where art institutions traditionally considered part of the more politically inclined margin of the art world showed themselves to be firmly on the side of the ruling powers.

I am thinking of the exhibition "Abstract Possible" at Tensta Konsthall in Stockholm, where Maria Lind collaborated with the auction house Bukowskis, owned by Swedish oil and gas exploration company Lundin Petroleum, responsible for killings and village burnings in Sudan. I am also thinking of the eviction of a group of Occupy activists from Artists Space in New York. In both instances we have an allegedly progressive institution revealing previously invisible elite-class alliances. It seems as if institutional surfaces are beginning to crack as we enter a period of intense crisis. In the winter things are stripped bare as the leaves fall and the temperature drops.

Although the booming art market is very much central to the story of contemporary art in the decades since 1989, the 1990s and 2000s were also a period of not only institutional critique, and different kinds of relational and participatory art, but also representations of anti-capitalist politics, which were exhibited in art institutions around the world. In tension with the escalating use of contemporary art as a haven for newly accumulated capital and a resource for regional or national development, art institutions mounted exhibitions focusing on ongoing political conflicts or, more often, presented historical political art (feeding the historicist impulse visible in much new art).

In Europe, we had biennials like Catherine David's Documenta X in 1997, with a heavy dose of late 1960s institutional critique, coupled with Marxist theory, Okwui Enwezor's postcolonial Documenta 11 in 2002 and the Brechtian 11th Istanbul Biennial

in 2009 organized by WHW. There were also large historical exhibitions like "Forms of Resistance" at the Van Abbe Museum in Holland in 2007, curated by Will Bradley and Charles Esche, encompassing art from the Paris Commune to Marco Scotini's Disobedience Archive. In the US, we had exhibitions like Nato Thompson's "The Interventionist: Art in the Social Sphere" in 2004, with the likes of the Yes Men at MASS MoCA and Chris Gilbert's notorious "Now-Time Venezuela: Media along the Bolivarian Process" at Berkeley Art Museum in 2006, which ended in Gilbert's resignation and exile in Venezuela.[4]

So, while contemporary art was in many respects "a propagandist of neo-liberal values"—as Julian Stallabrass writes in his *Art Incorporated*, showing how contemporary art became tied to post-Fordist speculation with bling, boom and bust—it was also a place where curators and artists were able to show political actualities not necessarily visible elsewhere.[5] The absence of a critical political public sphere made the art institution a place where it was possible to represent pressing political issues.

Although the alter-globalization movement and other anti-systemic movements tried to oppose neo-liberal dogma, neo-liberalism became a kind of second nature after 1989, acting as the most successful ideology in world history, as Perry Anderson wrote with a hint of hyperbole in 2000.[5] At a time when neo-liberal ideology managed to present itself as the only game in town, effectively turning any reference to alternatives into a slide towards totalitarianism, the representation of oppositional politics in the art institution was a welcome gesture. It was possible to discuss a wide range of topics in contemporary art excluded from the mass media, such as the rise of right-wing populism in Europe, communism and neo-liberal recolonization.

The art institutional representation was a positive antidote to the intellectual blackmail of the 1990s and 2000s, with its rhetoric of "the end of history" and "a clash of civilizations". But it was,

of course, itself limited by structural difficulty in connecting the representation inside to an outside political context, where it could acquire a broader radical perspective. In retrospect, the absence of opposition to neo-liberalism almost looks as the condition of possibility of "political" art in the 1990s and 2000s.

The contradictions of contemporary political art are, of course, structural by nature, as the historical avant-garde movements, and their contemporary critics like Benjamin and Marcuse, had already shown in the 1920s and 1930s, when the avant-garde tried to transcend the institution of art and set art free, outside the institutional confines of modern art. Marcuse's Weberian-Marxist analysis of "The Affirmative Character of Culture" in large part still holds true as a description of the double nature of contemporary art.

As Marcuse argues, on the one hand art creates images of another world and possesses a subversive potential thanks to its autonomy. Art is an expression of humanity's preoccupation with its own future happiness and in that sense transcends society at a symbolic level. It is a kind of sanctuary where a number of fundamental needs that are suppressed in capitalist society are met virtually. The victims of the rationalization of bourgeois society are given a voice and awakened to life in art, which in this way functions as a repository for marginalized experiences and excluded modes of expression. But on the other hand art is socially affirmative. It is a relative legitimation of the society in which it exists.

The freedom and autonomy of art is moderated by that very freedom being enclosed in the institution of art, "an independent realm of value [...] compatible with the bad present, despite and within which it can afford happiness."[6] Art thus stabilizes the very condition it criticizes, Marcuse writes. It is a place of hibernation for the anarchistic imagination that is rapidly being eradicated by the accelerated rationalization of capitalist modernity. But this imagination is also prevented from having

any broad social impact, precisely because it is confined to the sphere of art, because of art's autonomy. Marcuse terms this contradiction the dual nature of art—the fact that it is relatively autonomous, and both protests against capitalist society and its alienating abstractions, and confirms that society by being a safety valve whereby society can blow off surplus energy and let marginalized desire come to expression as pointless luxury goods with no risk of real change.

The fates of the avant-garde, the neo-avant-garde and institutional critique all confirm Marcuse's analysis, and stresses art's complex autonomy, which is both challenged and confirmed by the inclusion of politics in contemporary art. The management of cultural trends and "subversive" art is one way of maintaining social balance, as stressed by Marcuse, Adorno and Debord.

Since the late 1950s, art institutions have been reflective about this double character of art and have allowed or even welcomed political criticism of themselves, in order to keep the anti-autonomous or heteronomous side of art alive, reproducing the distinctness of art as a place of criticality in capitalist society. This development has intensified since the days of pop and conceptual art, making the representation of politics in art a necessary supplement to contemporary art's neo-liberal turn, where art was one way of defibrillating a slowing economy and entertaining the unproductive FIRE (finance, insurance, real estate) population. As Brian Holmes phrases it: "The institutional 'house' now seeks its interest in a complex game, which alone can reconcile the economic nexus it provides with the cultural capital it seeks among the more radical factions of the artistic field."[7]

In the 1990s and 2000s, several European art institutions were thus open to some kind of politicization, where curators were allowed to critically rework the institution and open it up, not only to more process-oriented art projects, but also to political

concerns. Rooseum in Malmö, directed by Charles Esche, and München Kunstverein led by Maria Lind, are among the well-known examples of this trend dubbed "new institutionalism". Now, the art institution was actively supposed to support criticality, and deploy institutional critique at the level of institutional administration and programming, not just mount exhibitions by political artists. The curator herself now had a "subversive" agenda working together with artists, enabling structural change of the institution.

The exhibition was no longer the privileged medium. Seminars, publications and different kind of archives became important formats whereby the audience, according to the discourse of new institutionalism, was transformed from a contemplative individual spectator into an active participant. Curators like Esche and Lind thus worked as in-house curators striving to enable critique, and transform the institution into an open and socially inclusive arena for the presentation of oppositional political representations of various kinds. In the words of Brian Holmes, some art professionals were apparently "playing a transformative game", trying to produce alternative ways of evaluating art and using it to progressive ends.

In a longer historical perspective, this move is to be understood as part of a general move away from direct critique, considered to be too totalizing, romantic and unable to challenge the object of critique. Instead, it was moving towards a loosely Deleuze-inspired idea of radical pragmatism, where you work within institutions, making "modest proposals" instead of rejecting them, as was the case, for instance, in the situationists' critique of the society of the spectacle in the 1960s.[8] Rhetoric of the temporary or open-endedness characterized the discourse of new institutionalism, where direct confrontation was replaced with implicit critique.

A few years into the crisis—as Arrighi writes, the crisis had actually already begun in the early 1970s, as the post-war

boom exhausted itself—it seems fair to say that the discourse of new institutionalism was really just one more example of depoliticization in art, where art institutions were temporarily transformed into social centres and discussion platforms, but nothing really changed. New institutionalism was the art world equivalent to the new managerial discourse analyzed by Luc Boltanski and Eve Chiapello. This transferred attitudes once associated with the artistic personality such as autonomy, spontaneity, openness to others and rhizomatic capacity.[9]

Art institutions followed corporate management, and adopted the rhetoric of social responsibility and sensitivity to difference, internalizing the neo-liberal hype of creativity and getting everybody to work more for less or for free, consolidating elite power. What took place was a destructuring and hollowing out passed off as critique and politicization. The modest proposals were not a threat to anyone and took place as yet another attempt to maintain social balance through the management of "radical" art.

The case of "Abstract Possible" at Tensta Konsthall is an interesting one. The collaboration with Bukowskis sheds a revealing light on the position of so-called progressive institutions as we move in to the winter of finance capital.[10] Bukowskis is the largest auction house in Sweden, owned by the Lundin family, who direct the oil company of the same name, a company complicit in civil war in Sudan and under investigation for humanitarian crimes against international law. That contemporary art has long served as an investment opportunity for the super-rich and a place for money laundering is old news, but the direct entanglement of a Kunsthalle in Sweden, of all places, with the weapondollar-petrodollar coalition, is pretty remarkable.[11]

The exhibition at Tensta itself was a straightforward group exhibition with works by more than 20 artists. It focused on formal abstraction, ranging from Yto Barrada's close-ups of bus doors,

with abstract shapes communicating bus routes to illiterates, to Matias Faldbakken's sloppily installed, overprinted silk screens of the computer game *Battlefield* developed by Swedish company EA Digital Illusions. All the works in the show somehow mimic the abstract visual language of modernism, but rarely with the radical negativity that characterized its historical precedents.

At Tensta, most works come off as symptoms of the lingering historicist academism in contemporary art, where modernist forms and shapes are reworked and commented upon in an almost nostalgic way. This serves to confirm the distance between the original radical gestures, and the present empty and weak restaging of modernist abstraction, as fascinating forms popular on the art market. The show continued at the Bukowski auction house in downtown Stockholm, where artworks by the same artists exhibiting at Tensta are for sale at set prices. One of the works on auction was a report by Goldin + Senneby about the opportunities for collectors by each of the works on sale. The report itself is on offer for 120,000 Swedish Krona and its contents available only to the buyer.

The implicit criticism of new institutionalism seems, in this instance, to have fused completely with the perspective of the neo-liberal art system. Rather than exposing and highlighting the economic structure of contemporary art, it is a blank confirmation of the system, as there is no attempt whatsoever to point in alternative directions. We are thus left with pure affirmation of the existing system, its art market and the owner's bloody petroleum politics. The process, through which cultural values are produced, circulated and accumulated, and for and by whom this happens, is left unchallenged. It seems as if the repressive tolerance of the 1990s and early 2000s is no longer an option, forcing artists to move closer to the ruling powers or to abandon art, or at least forsake institutional success.

The eviction of Occupy Wall Street protesters by security personnel from Artists Space in New York in October 2011 and

the eviction of graffiti artists from the São Paulo Biennial's Oscar Niemeyer pavilion by the police in 2008 are other cases to consider when trying to come to terms with the development of the cultural institution in the present conjuncture of crisis and ideological breakdown.

As we move into a global economic crisis, fractures and lines of conflict that have been concealed for some time are becoming visible, and it seems fair to say that a genuine anti-systemic break was never on the agenda for the new institutionalists. Indeed, nor was much of what passed as political art in the 1990s and 2000s in the institution. It was never an alternative to the ruling order and should in retrospect be understood as neo-liberalism with a human face. Now the masks have fallen, and the difference between cultural neo-liberalization and new institutionalism is difficult to locate. As Anthony Davies writes, they are not alternatives but "coexistent forms of neoliberalism, evolving at uneven rates and in different phases perhaps but all moving in the same direction". Now finally in a situation of breakdown, they seem to be merging.[12]

The masks have come off, and the intricate link between the cultural institution and elite power has been revealed for everybody to see. We are seeing signs of an ideological breakdown, where "progressive" institutions find themselves in a new situation in which it is difficult to continue the charade of new institutionalism's repressive tolerance. In this situation, we are confronted with a number of urgent questions. One has to do with the present past, and the different "politicizations" of art that took place during the 1990s and 2000s. In retrospect, it seems as if much of what presented itself as progressive and radical in the 1990s and 2000s was just a supplement to the neo-liberalization of art.

The ruling class continued amassing wealth, while art exhibitions were turned into parties or discussions about postcolonialism and economic inequality. This forces us to

ask whether or not playing a transformative game within the institution is still a viable option. What to do then? Although an exit from the institution looks increasingly desirable as the institution reveals its class character, it is perhaps not altogether wise, as we will need all available sources of criticality in the fight to come. But considering the ability to manage radical art and divert it in order to maintain social equilibrium—Marcuse's affirmative character of art—it seems reasonable to say that only art sited at the very margin of the art system can help to build a passage beyond capitalism. In the coming insurrection, the safe interior of the art world will perhaps become too compromised.

Being financed by and collaborating with Lundin was not a problem for Tensta and Lind. As Lind explained during a debate about the exhibition where an accompanying anthology, *Contemporary Art and its Commercial Markets: A Report on Current Conditions and Future Scenarios*, financed by the auction at Bukowskis, was launched: "The project is not about taking a position, this is what the world looks like." This is what complicit criticism amounts to these days. Apparently, all we are left with is identification with the existing system. Luckily, this logic is being contested more and more in places all over the world from Athens to Cairo to Oakland to Sarajevo to Hong Kong to Paris. Winter is here.

Chapter 4

The Long March Through the Institutions

In 1967, at a debate in Hamburg on the nature of the West German student movement, Rudi Dutschke stated that:

> The revolution is not a quick act that takes place once and transforms everything right away. The revolution is a long, complex process... Two years ago we were just a bunch of small esoteric groups believing we were the world spirit. Today the movement is thousands of people. But the transformation process will be what I have termed a long march through the existing institutions.[1]

Borrowing the term the "Long March" used by Mao to describe the 9000-kilometre retreat and regrouping of the Red Army of the Communist Party of China in 1935, Dutschke affirmed his belief in a revolutionary transformation of capitalist society. Dutschke was not alone in developing an idea of a progressive use of the institutions of capitalist society at that time. In the late 1960s, both the anti-authoritarian New Left, as well as parts of the artistic avant-garde, shared a belief in the need to transform society through the existing institutions.

In retrospect, many concepts and ideas from the late 1960s often appear problematic today, and difficult to put into practice now that the heyday of agitated critique has waned and has been replaced by repression, depression or new neo-liberal modes of being. But the idea of a long march through the institutions does not seem completely out of date. Ideas like cultural revolution or workers' self-management carry their historical weight in a more obvious manner than the idea of a long march through the institutions. The promises and failures of ideas like the cultural

revolution and self-management seem to have destined them to oblivion. But not so the concept of the long march through the institutions.

In recent years, the idea has resurfaced both explicitly and indirectly in politics and art. We find it in *The Kilburn Manifesto* written by the late Stuart Hall. We find versions of it in the work of cultural theorists like Mark Fisher, who contemplates taking over cultural institutions. It is also present in accelerationism, and the idea of a progressive use of the institutions of capitalist society, and it is of course to be found in political phenomena such as SYRIZA in Greece and Podemos in Spain.

The following chapter is a brief discussion of the question of the notion of the institution and its potential for progressive use. I would like to start out by asking whether or not Dutschke's notion of a long march though the institutions can help us in the present situation of crisis and breakdown. What did Dutschke mean by "the long march through the institutions"? And what are possible parallels between the recent discussion of a return to, or critical use of, the institution for artistic and political purposes, and the ideas espoused by Dutschke?

Looking at Dutschke, we are immediately confronted by a historical paradox, because while most contemporary theorists use the term of the "long march" as a description of a progressive but, as I argue, largely *reformist* political project, Dutschke was describing a *revolutionary* process. His goal was a communist revolution: nothing less than a complete overhaul of capitalist society. Dutschke was an anti-authoritarian communist active in the West German student opposition movement in the late 1960s. After joining the German SDS (Sozialistischer Deutscher Studentenbund) in 1965, Dutschke soon became its most prominent voice and quickly came to play a central role in the mobilization of the West German youth against the Vietnam War in the late 1960s.[2]

Referring to, among others, Herbert Marcuse's analysis of

the one-dimensional society, and also, of course, Marx's critique of the political economy and analysis of the capitalist mode of production—which had created an independent and alienating power running society without any consideration for human needs—Dutschke criticized not only a repressive West German state unable to come to terms with its Nazi past, but also the booming post-war capitalist society, and the new forms of control and submission it had created.

The phrase "the long march" was used by Dutschke to conceptualize the revolution as a large and long-lasting project. This consisted not only of a quick overhaul, but also a *coup d'état*, in which the revolution was a quick fix taking place from one day to the next. The revolution, however, was a much more encompassing and complex process, he argued—thus the idea of a long march. As Dutschke stated in a television interview with Günter Gaus in 1967: "The difference between past revolutions is, among other things, that our revolutionary process will take a long time. It will be a very long march."[3]

According to Dutschke, it was not possible to reform the existing institutions, including the West German Parliament. The point was thus not to reform the institutions, but to use them in the revolutionary struggle and somehow make them obsolete from within. The institutions had to be overthrown through a sustained, internally differentiated revolutionary process that consisted of a hostile takeover of the institutions and illegal activities outside. It was never just a question of running the institutions, but always a question of creating something different.

Dutschke's vision of "the long march through the institutions" was based on a firm belief in the possibility of radical historical change. His notion was part of a larger rediscovery of earlier revolutions that had taken place in the years from the mid 1960s to the early 1970s, in which militants, workers and students looked back and reconnected with the great proletarian offensive from

1917 to 1921, effectively shaking capitalist society. Dutschke, for his part, not only discovered Georg Lukàcs and Lenin, but also drew on Dutch and German council communists, like Anton Pannekoek and Karl Korsch. He also read Amadeo Bordiga, coming up with plans for the creation of an autonomous Berlin Commune based on the lessons of the Paris Commune of 1871, as well as the short-lived Bavarian Council Republic in Munich in 1919.[4]

As we all know, Dutschke's project did not succeed. He abandoned activism and had to leave Germany, settling in Aarhus in Denmark, and writing a dissertation that critiqued Lenin's understanding of the relationship between Russia's semi-Asiatic mode of production and its capitalist development. Western European protest movements fell apart quickly after the explosive events of 1968, except in a few countries like Italy and Portugal. Here, the movements were able to continue the struggle for a number of years before finally being swept aside by a counter-revolutionary offensive, which included substantial state violence and repression in the early 1970s. This paved the way for a dramatic restructuring of not only the global economy, but also everyday life.

The sites of the most militant European workers were closed down, and the deindustrialization of Western Europe and the US began to take place on a large scale. Over the course of this process, workers in the centres of accumulation were replaced by much cheaper Chinese workers. This development—the emergence of neo-liberal globalization—began to take place on an everyday level. In this context, elements of the 1968 movement's critique of boring Fordist work were replaced by a new individualized and hedonistic discourse of consumption and creativity. This effectively produced what Boltanski and Chiapello have termed a new capitalist spirit, in which components and fragments of revolutionary demands are transformed into non-threatening neo-liberal substitutes.[5]

This development also took place on a more individual level, in which the long march through the institutions turned out to be a somewhat different project than the one conceptualized by Dutschke: revolutionary critique was replaced by careerism. The later development is perhaps best personified by figures such as Daniel Cohn-Bendit and Joschka Fischer. Cohn-Bendit was the infamous German-born student leader in Paris, who was expelled from France by the authorities. This act prompted a wave of Parisian students to take to the streets shouting "We are all German Jews!" in defiance of the attempt to cut off the head of the protest movement.[6]

After being active in the radical left-wing scene in Frankfurt in the early 1970s, Cohn-Bendit joined the environmental movement before becoming a member of the German Green Party in 1984, ending up as an influential member of the European Parliament and a staunch defender of the EU. Cohn-Bendit's friend Fischer was part of the same ultra-leftist milieu in Frankfurt, heading a small militant street-fighting group called Putzgruppe. However, he later became the leader of the Green Party and Foreign Minister from 1998 to 2005 as part of Gerhard Schröder's social democratic government that enacted a number of neo-liberal policies, most notably the so-called Hartz IV welfare reforms.

Break or Complicit Critique

Of course, within art there was also a partial rediscovery of previous revolutionary projects, in which the so-called neo-avant-garde revisited movements dating from the interwar period. Particular focus was given to the critique and ridicule of the institutional status of art, and an interest in lending art a function beyond the confines of the art institution. Avant-garde groups like the SI sought not only to continue the projects of Dada and surrealism, but also to give them a more pronounced and explicitly revolutionary dimension. This resulted in the

dispute of 1962 about the redundancy of art (not only in the narrow sense of artistic media, but also in terms of the art institution in general) as a means for revolutionary critique— especially in a capitalist society that increasingly depended on the production and circulation of images of a pleasant life filled with commodities, and the representation of the threat of nuclear extension.

The fraction of the situationist group led by Guy Debord sought to leave the art institution behind and propagated engaging in what they termed "a revolutionary art of war". This was to be achieved not only by analyzing the society of the spectacle and its image-based forms of domination, but also by practising subversive behaviour on the margins of society, living the revolution within a hostile and occupied environment. Although their radicality and all-out avant-garde attack on art were unique, the situationists were not alone in trying to move beyond the institutional framework of art. Artists active within the Fluxus and Happening movements likewise sought to put art to use outside the frameworks of the institution and the market.

A different approach was presented by artistic practices that came to be known as institutional critique. Instead of trying to leave the institution, artists like Daniel Buren, Hans Haacke and Michael Asher all sought to expose the institutional framework and aesthetic norms of modern art from within— working from the assumption that it was impossible to exit the institution completely. The situationists were forced to leave art behind in favour of what they hoped would be revolutionary activities, while the artists associated with institutional critique stayed behind and practiced subtle displacements within the institution, not believing that it was possible to occupy a "free" realm outside art, beyond recuperation.

Peter Bürger's 1974 classic, *Theory of the Avant-Garde*, thus retrospectively can be described as a contemporary literary and historical account of the emergence of institutional critique,

which analyzes the recuperation of the historical avant-garde by the post-war neo-avant-garde, Fluxus, pop, etc. Bürger argues that these groups and movements only managed to stage and represent *within the institution* radical gestures aimed at challenging the institutional status of art. Essentially, the avant-garde was now safely included in the very institution it had originally called into question.[7]

Bürger's book was written in 1973 to 1974, at a time when the revolutionary energies of the 1960s were rapidly dissipating in West Germany and most other places. When Bürger published his book on French surrealism in 1969, *Der französische Surrealismus*, the situation was different; in this text he explicitly linked surrealism with May 1968 and the student movement. By 1974, the situation had changed and Bürger chose to condemn the neo-avant-garde, implicitly identifying the Marxist historian — in other words, his own position — as the last refuge of criticality. This was because the historian could now engage in ideological critique as a kind of theoretical class war.[8]

Within the discourse of art, institutional critique ultimately had a more lasting impact than the situationists. In the early 1990s, artists like Andrea Fraser, Fareed Armaly, Fred Wilson and Christian Philip Müller relaunched institutional critique, not only analyzing the museum and gallery, but also the role of the artist, by focusing on the forms of artistic subjectivity permitted and produced in the art institution. Although this approach was, to a certain extent, already present in the works of artists like Marcel Broodthaers, the new generation made visible the conditions of possibility for the artist to perform, or engage in, critique of the institution. This is exemplified by Fraser's performances, in which she is/performs a stressed and incoherent museum guide.

But this turn towards yet another level of metacritique somehow moved institutional critique even further away from any kind of revolutionary critique. It ultimately made the self-

critical artist into a tired, desperate and cynical post-political artist convinced of the almost ontological impossibility of ever exiting the institution or being able to reach a non-art audience. Fraser summarized the position in 2005: "We are trapped within our field." Not only was there no outside, but it was not even possible to envision one. She continues: "With each attempt to evade the limits of institutional determination, to embrace an outside, we expand our frames and bring more of the world into it. But we never escape it."⁹ Complicit critique thus became dangerously close to a defeatist stance, in which any real critical potential was suspended.

Art and the figure of the artist, as conditioned by capitalist society, were not the only part of the problem. Since art was simultaneously able to articulate a muted critique of capitalism while consolidating of capitalist society, it had become the main problem. Institutional Critique ended up trapped in the institution, becoming a Biedermeier version of criticality, which works comfortably from inside the institution, paying it the ultimate homage of being "deconstructed".

In this context, it does not make sense to engage in a post-situationist escape attempt, because everybody prefers the compromised prestige and benefits of the art world, which at best minimize and isolate larger social issues within the field of art. The conclusion is bleak and pretty clear: in light of the notion of "the long march through the institutions", the institutional critique of the 1990s ends up looking like an internal exercise doomed to remain within the closed circuit of the field of art.

Failure or New Beginning

Within the last few years, we have seen yet another turn when it comes to the question of the institution. One aspect of this development stems from the financial crisis of 2008 and the rise of a global protest movement resisting the austerity programmes that most European nation states opted to implement in order

to socialize the losses of financial breakdown. This protest movement was the first large-scale opposition to form after a 40-year-long neo-liberal crash landing, during which living standards have fallen, and more and more people all over the world have been forced into precarious labour, or simply find themselves excluded from the process of capitalist production altogether.

Although the financial crisis has not caused any real political changes to government policies across the board, it does represent a major ideological breakdown in neo-liberalism, which now seems unable to re-establish its previous dominance. No new ruling ideology has yet been formulated, and we seem to be headed into a long period of geopolitical chaos defined by competing major powers and the slow dismantling of US hegemony.

In this new situation of crisis and breakdown—in which the nations of the EU have been forced to undertake draconian austerity measures, and nations in the Middle East and North Africa have been turned into battlefields—there have been attempts to formulate visions for retaking the institutions hollowed out by the tumult of neo-liberal reform. Mark Fisher, for instance, has argued that now might be the time to embed oneself in old institutional forms like the BBC, the Tate and the Labour Party.

After decades of being hollowed out by neo-liberal changes and cuts, these institutions are there for the taking. The Left must re-enter political and cultural institutions, putting them to a new use. As Fisher writes: "Mainstream media" is not "a monolith but a terrain" on which to fight and engage in "popular experimentalism". We shall neither "remain in the margins nor replicate the existing forms of mainstream", Fisher notes.[10]

This means taking back the institutions that the Western working-class and labour movement helped create over the course of the 20th century through intense and persisting clashes

with ruling powers. The social democratic Left in Western Europe gained power through these institutions after World War II and Fisher is proposing to do the same today. We have to reactivate the institutions of the nation state and put them to progressive use, as was done in an earlier period.

In a text co-written with Nina Möntmann, Fisher explicitly links his argument to the financial crisis, writing that "since the financial crisis of 2008, the ideological field is radically open in a way that has not been the case for at least thirty years. [...] In other words, the ground is for the taking."[11] Fisher and Möntmann present their argument as a critique of a certain Deleuze-Negrian stance, which they consider obsolete as a result of the crisis. Negri's notion of exodus and Deleuze's lines of flight might have been relevant in an earlier period but, in fact, they only mirrored the rhetoric of networks and participation propagated by neo-liberal management. We now have to move back into the institutions in a kind of Gramscian project, Fisher argues.

Fisher and Möntmann refer explicitly to Gramsci and his notion of hegemony via Chantal Mouffe, from whom they draw their political and philosophical vocabulary. In a talk presented at the "Truth is Concrete" event in Graz in 2012, Mouffe outlined a project of engaging strategically with institutions in accordance with "a pluralistic perspective".[12] In opposition to attempts to move beyond the institution, Mouffe advocates a return to institutions as a way to "challenge the dominant consensus" and help produce a new common sense — effectively breaking down the hegemonic order.

Critical artistic strategies can play an important role in this challenge to the common sense of neo-liberalism, paving the way for an agonistic political practice of "establishing a new hegemony", says Mouffe. We are involved in a discursive battle against neo-liberalism and the task is to develop a new form of competing "common sense". In order to do this, we have to get back into the institutions. As Mouffe says: "The long march

through the institutions cannot be averted."[13]

Both Fisher and Mouffe advance an ideological critique of neo-liberalism, thus contributing to the important critique of ruling representations of neo-liberal globalization. They focus on neo-liberalism as a political ideology to be fought discursively in both cultural and political spheres, and also in the institutions of civil society, most of all the media. However, the problem is that they only focus on neo-liberalism as an ideology and they therefore end up drawing from a fairly restricted notion of the revolutionary potential in the use of the institutions. In short, the problem with both Mouffe and Fisher's discourse is that neither of them actually envision "the long march through the institution" as a genuinely revolutionary process; it's all about reforming the institutions and putting them to a different use.

Revolution is reduced to a question of a different "politics". Their argument is framed around the question of political choices. But what conscious "choice" or decision did the socialist Mitterrand make, when he did not carry out nationalizations as promised after gaining power in France in 1981? Or was perhaps something else at stake, which was related to the structural transformations of the world economy starting from the early 1970s?

During this time, advanced economies began experiencing difficulties and found themselves unable to maintain profit rates, which caused them to shift production to less costly places ("cheaper workers"). Mouffe's proposal hinges on what we can call a foreshortened analysis of neo-liberalism, in which the logic of capitalist economy is missing from the analysis and the return of the objective crisis tendencies of capital somehow disappears from her description.

Mouffe and Fisher reduce the pervasive transformations that have taken place over the last 4 decades to a question of ideology and politics. On this narrow basis, they argue for a new use of the institutions of capitalist society. Confronted with the accelerated chaos—the meltdown of the biosphere and the growth of the

world population, in addition to global economic shifts that economically disenfranchize hundreds of millions of people— Mouffe's proposal seems highly lacking and completely out of touch with reality. Merely using the institutions of capitalist society in a different way is far from enough. We have to go much deeper and be much more radical in going to the roots of the problem, if we are going to address the inherent shortcomings of the capitalist mode of production.

As Robert Kurz has explained, capitalism is "domination without a subject", in which the subject is not people but capital.[14] It is thus not a question of different politics or a new common sense; it is not a question of the wrong class running the economy. The economy is the problem. The forms of social relations in capitalism, as mediated by labour, have acquired a life of their own—independent of the individuals who participate in their constitution. It has become an objective system in which "the circulation of money as capital is an end in itself", as Marx once wrote.[15] Running the institutions of capitalist society and controlling the production of surplus value is equivalent to orchestrating your own alienation.

For Dutschke, the point was to dismantle the institutions from the inside with a view to creating something completely different: a communist society. Dutschke emphasized the ideological dimension of class struggle, but he did not reduce it to politics, as Mouffe and Fisher tend to do. The long march through the institutions was one moment in a two-part war against capitalist society, in which institutional work and extra-parliamentary praxis went hand in hand; although the one could never exist on its own.

The goal was the negation of the negation of capitalism; in other words, the abolition of capitalist society and all its mediating forms, such as money and wage labour. But this perspective is never articulated by Mouffe or Fisher, who only engage in a kind of "culturalist" critique of neo-liberalism. In doing so, they join

the late Stuart Hall, who tried to reignite a post-war reformist Left in *The Kilburn Manifesto* (2015), breathing new life into the Labour Party, the unions and the BBC, in an attempt to roll back the destruction of the post-war welfare state.[16] The welfare state was a tremendous achievement of the Western working-class movement, realizing the democratic project that the bourgeoisie was never able to attain.

At the same time, it also meant the abandonment of a revolutionary perspective and turning a blind eye to the wretched of the Earth in the rest of the world. Regardless, there is no New Deal to be made. Over the last 40 years, capital has excluded more and more workers from its metabolism, and the process seems to make a new wage-productivity compromise unlikely. The "good" thing about the crisis is that it will become much worse, exposing attempts to use the institutions of capitalist society as insufficiently radical. As Toni Negri says: "There's no New Deal."[17]

We are trapped in an economic crisis that does not seem to end. In this situation, the state takes on the form of a cuts-and-anti-rebellion regime. The state is, in the words of Nicos Poulantzas, more domination than political battle right now and whatever the state may do, it will be in favour of capital.[18] It is thus an open question as to how much revolutionaries can use the existing institutions in the coming battles. Certainly, it will be less than Mouffe and Fisher envision.

In the present situation, returning to the original notion of "the long march through the institutions", in which any use of the institutions is held in check by illegal actions outside, would not be a bad start. Perhaps this will enable us to avoid the worst reformist pitfalls, and remember the revolutionary project of moving through the institutions while destroying them and then exiting. Most institutions have to go. That was the plan and that remains the plan. As Dutschke phrased it: "We can no longer formulate the question of reform."[19]

Chapter 5

Globalization, Architecture and Containers

"Power has become environmental itself, has merged into the
surroundings."[1]
The Invisible Committee

In 2013, the BMW plant in Leipzig was named the best factory
in Europe by the Federation of German Industries and INSEAD,
the former European Institute of Business Administration. The
factory was "selected for being one of the world's most modern
car production plants". "This year's winner illustrates the
importance of entrepreneurial thinking to strengthen innovation
in European manufacturing," the committee stated.[2] The plant,
designed by Zaha Hadid Architects and built from 2003 to 2005,
had already received a number of architectural awards, such as
the Deutsche Arkitekturpreis 2005 and the RIBA European Award
in 2005 for "excellent architectural work". Both the business and
the architectural committees awarding the prizes single out the
plant's transparent and dynamic character, the fluidity of the
building and the efficiency of the production going on inside.

According to Zaha Hadid Architects and BMW, the building
enables innovative working-time models from 70 to 140 hours per
week, making it possible to adapt extremely quickly to specific
changes in the market. As such, the factory is, of course, part of
a broader development, in which European car manufacturers
adopt the so-called Toyota system of lean and just-in-time
production, reducing flow times within production as well as
response times from suppliers.

The factory in Leipzig employs 5500 workers and each day
650 BMW 3 Series cars pass through the building on an elevated
conveyor belt, enabling the plant to produce up to 1.4 million

vehicles per year. At first glance, the central building of the BMW plant in Leipzig appears both transparent and dynamic. The space is clean and almost aseptic; the building bathed in white light, intermixed with blue LED lighting from the conveyor belt. It is internally transparent, and characterized by lines and flows on the inside, but closed on the outside. Flexibility is the key word but, of course, it all comes down to producing cars or "ultimate driving machines" as BMW calls them. Today, producing and selling cars involves an expanded portfolio of aesthetic means, including expressive architecture and new labour practices.

For a long period, from the late 1970s to the early 1990s, Zaha Hadid was primarily known in architecture schools as a deconstructive avant-garde architect influenced by Russian suprematism, rethinking the representational modes of architecture by creating flowing, bristling forms.

The Anglo-Iraqi architect established herself as a major figure in contemporary architecture in the late 1990s and 2000s with a number of major projects and buildings in the US, Europe and the Middle East: Vitra Fire Station in Weil am Rhein, the MAXXI Museum in Rome and Heydar Aliyev Cultural Centre in Baku, among others. If, once, she was the architect who always accompanied her failed competition entries with strange kitschy, yet quite dynamic, Malevich-like paintings, she is now among the most prominent living architects. Opera houses, museums and cultural centres have sprung up in recent decades in Hadid's signature style, which is often characterized by displays of superhuman formal complexity, part extravagant architectural gesture, part freewheeling computational design system.

The partnership between Hadid and BMW makes perfect sense. Hadid's plant in Leipzig is a present-day example of what the Italian Marxist architectural historian Manfredo Tafuri (picking up the term from the German art historian Adolph Behne) termed "advertising architecture" [*Reklamarchitektur*] in the 1920s, in which architecture becomes a kind of mass

communication of the urban restructuring taking place within contemporary capitalism.

As Tafuri argued in his readings of the German expressionist architect Erich Mendelsohn, architecture is subsumed by the economic and technological development of capitalism, in which architecture comes to express this transformation.[3] Hadid and Patrik Schumacher, Hadid's right-hand man and chief theorist, talk about the BMW plant as somehow involving or expressing an "urbanization of production". What this means is that the building is meant to reproduce the complexity of a city, and use its endless quantity of expressions, affects and languages.

Hadid's BMW plant is, of course, caught in the modernist dilemma of having to confront economic and urban restructuring on the tiny scale of individual buildings. This is the inescapable paradox of modernist architecture, where buildings somehow have to negotiate and negate its (capitalist) surroundings, and, of course, are unable to do so (as individual buildings). Hadid makes signature pieces that cannot compete with the structural transformations taking place, and ends up reproducing them as architectural gestures or a style of flexibility and expressiveness.

Hadid's BMW plant is a latter-day example of the architectural affirmation of the conditions of capitalist globalization, in which star architects draw spectacular signature buildings for corporate capital. The overlap between the rhetoric of BMW and Zaha Hadid Architects is telling: they share a particular language of innovation and creativity. BMW has used the 2005 building in TV commercials, highlighting the obvious nature of the "collaboration" with Hadid: "We could have built a plant like any other. We also could have said 'no' to thousands of leading design concepts developed by our engineers, but at BMW we believe everything we do should express our support of great thinking, letting great ideas live on becoming ultimate driving machines."[4]

It is all about representation. Companies like BMW thrive on

a rhetoric of transformation and constant production. The brand of the company, the status of the architect and the iconicity of the building fuse, turning architecture into a gigantic three-dimensional advertisement for neo-liberal capitalism. Together with BMW, Hadid has created a kind of ultimate architectural production machine, manufacturing a staggering number of cars each day.

As Hal Foster writes, it is hard not to think of Peter Bürger's notion of a farcical repetition of the avant-garde's once-transgressive experiments. Hadid's use of the visual vocabulary of suprematism and expressionism is dangerously close to being a mere stylistic repetition of once-radical gestures, now in the service of corporate capitalism.[5] Hadid has chosen to work with a car manufacturer. We have come a long way from Tatlin's "Monument to the Third International". Where Tatlin, Malevitch and El Lissitzky rushed to the aid of the Bolshevik party after it took power in Russia in September 1917 and enrolled in the party's propaganda machine, Hadid builds for BMW and rich oil sheikhs. Nor is she alone. A whole generation of major architects has exclusive clients, building museums, alpine ski jumps and showcase corporate buildings.

This can only be understood, following Bürger, as an evacuation of the avant-garde's ambitious project of building a new world—dynamism has been emptied of its once-political dimension and now appears as nothing but the architectural expression of post-liberal or neo-liberal capitalism, to paraphrase Jameson.[6] It is impossible to avoid the question of recuperation when looking at Hadid's BMW plant, and it is necessary to ask whether or not it is possible to be both a builder of prestigious spaces of capitalist accumulation and an avant-gardist. If that is the case, then the idea of the avant-garde has been emptied of any kind of progressive politics.

The most striking feature of the building is the giant conveyor belt running across it, effectively breaking down the separation

of production and conception/design. All of the stages involved in the creation of the BMW 3 Series are visually present in the central building, which connects three pre-existing and previously separate production units, disrupting the separation of blue- and white-collar workers.

Executive management and production take place in a kind of uninterrupted visual flow, with cars moving on top of or just alongside open office spaces scattered throughout the building. Factory workers and managers are brought together in the same building, making visible the interrelationships between their work. Instead of separate floors with specific functions or programmes, the building is composed of a flow of openings, inclines and cantilevers, which open up the floor plates, creating an impression of openness and movement. As Hadid herself explains, "The idea is that you have a wide range of activities happening together in one space."[7] Hadid conceptualizes this as "the transformation of production into an urban field".[8]

The administrative and executive offices of the central building follow a fairly conventional post-war, open-office architectural style, yet Hadid has placed them in a moving architecture, in which there are few normal floor slabs. This places the offices in the open "landscape" of the building, dissolving the distinction between floors, activities and work hierarchies. The building thus effectively appears as one large organism or car-producing machine, where cars move around inside the building, and workers collaborate in an expanded and rhizomatic work flow in one large room. This abolishes (at least visually) the distinction between material and immaterial work. The different work activities morph into each other, and the architectural elements of design, administration, showroom and production inter-articulate.

There is a strong emphasis on horizontality in the building, placing all employees at the same level, working on the cars that move slowly inside the building. It's all about horizontality and

circulation. Circulation is emphasized not just by the cars and the workers who work on them while they are moving along the conveyor belt, but also by the building itself, with its flow of openings and inclines, likewise articulating continuous movement. The building's circulatory pattern forces workers to pass the so-called audit bureau in the middle of the building, where cars are selectively removed from the production process for inspection.

All employees must thus participate in the communicative process of producing knowledge (and cars). It is not enough to press buttons or tighten screws; you have to speak up, and be part of the collective enterprise of making and assembling the BMW 3 Series cars. This communicative demand on the workers, and the transparency and circulatory characteristic of the building, produces a distinctive working environment that we could describe as sophisticated self-control. This references Gilles Deleuze's description of the society of control, in which power has become immanent to the workers in the sense of workers controlling themselves through architecture and the built environment.[9]

The workers are precisely *not* monitored, but effect an ongoing control themselves. The plant is thus not only part of a transition from Fordist standardization to post-Fordist flexibility, but also takes part in the transition from a disciplinary society towards a society of control. In this transition, the separate institutions of disciplinary subjectification (family, school, army, factory, prison, etc.) are replaced by a flexible network of internalized control, where the individual is subjectified at all times by the now-fused institutions, working/exercising/dating/communicating 24/7. Instead of an external power overseeing the plant, we have a transparent and dynamic space in which workers are always visible to each other, communicating and participating in production.

There is a sense of "communality". Everybody is (forced

into) participating in a joint project, and everybody's opinion is necessary for competing and meeting the requirements of the unpredictable market. In this sense, it is not just the BMW 3 Series that is produced in Hadid's building, but also the workers themselves. The BMW Leipzig plant is not content with putting the workers' labour to work in order to create surplus value and profit; the factory wants their opinions and inputs. They *must* participate.

The autonomist-inspired sociologists Dimitris Papadopoulos, Niamh Stephenson and Vassilis Tsianos have described the plant in Leipzig as a "post-liberal space", simultaneously open and closed. In this environment, workers and management are stripped of their class belongings and subjectivities, and transformed into a kind of imagined commonality that transcends ideas of a people, citizens and civil society. According to the three authors, the factory represents a new phase of transnational capitalism: the erosion of the nation state's political sovereignty is followed by capitalism's creation of a space in which the BMW factory can "condense economic, technoscientific, political and cultural power", becoming a "vertical aggregate of power".[10]

This is not the realization of a liberal idea of the open society, but instead the coming into being of a space beyond politics, in which deterritorialized state functions merge with advanced technology and expressive architecture.

The BMW plant is an interactive order, neither open nor closed, but open as soon as it incorporates the actors necessary for its functioning, and closed as soon as it can protect and sustain its functionality. [...] It is an aggressive structure, opposing everything that sets limits to its own internal interests or tries to infuse it with impurity.[11]

The factory in Leipzig is an example of a new type of space in which the sovereignty of the nation state is replaced by post-

liberal aggregates of power, with capital including and excluding workers as it sees fit, in accordance with the invisible hand of the global capitalist market.

An immense accumulation of containers

If Hadid's BMW plant in Leipzig is the flashier architectural self-image of contemporary capitalism, the container might be a less visible, but nonetheless even more important, figure in the present phase of capitalist globalization—two seemingly neutral objects that have been instrumental in creating a new world, a world of self-control (of workers) and continuous movement (of commodities). The container paving the way for a complete restructuring of the world economy, deindustrialization of the West, and the intense capitalist modernization of China and South East Asia, and starchitecture being the self-representation of this post-liberal world.

The container is the invisible condition of possibility of Hadid's spectacular factory. Most of us rarely see the enormous quantity of containers that move around the world, containing all kinds of objects and gadgets, from Japanese fashion to frozen fish from Vietnam, rubber dolls from China to tomatoes from Spain or oranges from Israel. There is a huge network of infrastructure, technology and workers that remains invisible for those of us who only engage with the contents of the containers as consumers. But the container plays an integral part in contemporary capitalism.

The current period is usually addressed through terms such as globalization or neo-liberalism, but both terms tend to reduce the discussion to either a question of international trade or one of a new economic doctrine, thus missing the underlying material transformations taking place since the early 1970s. We are currently—after the economic crisis erupted in 2007 to 2008—living through a questioning of neo-liberal ideology, yet the underlying material structures remain largely intact. The

container is a key ingredient in this structure and if factories such as Hadid's BMW plant in Leipzig are beginning to appear as nothing more than "an architecture of spectacular, hollow unreality" (as architect and writer Sam Jacob recently wrote in the pages of *Architects' Journal*, in one example of the growing critique within architectural criticism of such spectacular corporate projects as Hadid's), the container remains out of sight and is rarely the object of any kind of critique.

As Marc Levinson has shown, the container is not just a box in which things get shipped around the world. It is not just the most important means of transport for the vast majority of goods with which we deal every day. The container is the coming into being of a new economy, in which manufacture and retail are integrated to a completely new extent, harmonizing the rhythms of production and consumption. As such, the container *is* globalization (as a new regime of accumulation).

"The container made the world smaller and the world economy smaller," as Levinson writes.[12] In 2012, there were over 20 million intermodal containers in the world. As Thomas Reifer states, were Marx to analyse contemporary capitalism, he "might have begun his analysis of capital by analysing the container," trying to account for the fact that "the wealth of the nations of the 21st century increasingly appears as an immense collection of containers."[13]

The container has been pivotal in the generalization of just-in-time production, enabling coordination between suppliers and buyers, which has made it possible for retailers to invert the traditional relationship between buyer and seller. Instead of having to stockpile goods, today's retailers can rapidly replenish their stocks. Speed and timing is everything in this new system, which moves so fast that it looks as if goods are produced when they are sold. Supply and demand are linked, and (ideally) only the goods that consumers are buying get produced.

Today, factories do not generate massive stockpiles of goods

that retailers promote and try to sell; with the container and just-in-time production, suppliers and retailers are functionally integrated, sharing so-called point-of-sale information. Commodities are pulled through the supply chain by actual demand and not by forecasted demand, the logic being that if the commodity is not sold, there is no point in producing a replacement.

The container has effectively helped create a global circulation system, eliminating standing inventory. If goods are not moving in this system, they are deemed useless. Things must move. And must move quickly, virtually at the speed of information, connecting container and computer into a "machine that changes the world", as a bestselling study of the just-in-time production at Toyota states.[14] Container and computer become one integrated machine, creating a global delivery system populated by a global workforce (that is forced into competing for wages). As Alexander Klose writes, the container "transforms the world into a moving warehouse and arranges it in the mode of standardized movable spatial units, switched processes, and clocked times."[15] Costly warehousing has been replaced by a continuous flow of information between manufacturer and supplier, enabling the delivery of custom-built parts in exact proportion to current needs.

With the advent of containerization, Toyota Motor Corporation's business model was expanded and became the production model not just for South East Asia, but also for large parts of the Western world, effectively revolutionizing the economy. The spread of the Japanese production model was made possible by the container. Containers had been used for a long time in land and water transportation, but it was only in the late 1960s, during the Vietnam War, that containerization took off as a generalized principle.

Truck company owner Malcolm McLean had already introduced standardized stackable shipping containers in the

1950s. But it was his company's ability to solve the logistical nightmare of the US army in Vietnam—bringing in and feeding an army of several hundred thousand soldiers in a country 700 miles long, with only one deep-water port, a single railway system and a fragmentary road network, mostly unpaved—that led the way for intermodal transport. McLean had realized early that "the shipping industry's business was moving cargo not sailing ships," but "it took the United States' painful campaign in Vietnam to prove this revolutionary approach to moving freight."[16]

When the US military and government experienced first-hand what McLean's containers could achieve, it immediately launched a national standardization process, which paved the way for intermodal transport. With the huge army contract, McLean quickly made another important move, filling his empty container on the way back to the US with Japanese goods. Thus began the transformation of first Japan, then the East Asian economies of Hong Kong, Singapore, Taiwan, South Korea and eventually China into the production site of the world. The deindustrialization of the West and the dispersal of the militant workers in the industrial centres could begin.

The container thus not only offered increased speed and security (the box could be packed at the production site and then unpacked by the retailer), but it also meant savings on both freight bills and wages. The container made shipping cheap and enabled transport businesses to get rid of the armies of rebellious workers who used to occupy the ports. The workers who used to make their living loading and unloading ships in ports disappeared or were replaced by technology, thereby eroding the power of the historically strong unions operating in harbours in the US and Europe.[17]

The turn to neo-liberalism we associate with Reagan's breaking of the air flight controllers' strike in 1981 and Thatcher's war on the UK miners, which culminated in 1985, took place even earlier

in the ports. The 1971 ILWU strike on the US West Coast marked a turning point and was the final success of the longshoremen's union in the US. The container showed itself to be an important weapon in the violent counter-revolutionary response to the militancy of the 1960s, in which workers in the US and Europe rejected the post-war Keynesian wage-productivity deal.

Stretching production and merging it with transportation meant that companies did not have to deal with the organized workers of the post-war era, who could stop the production of commodities in the factory. Commodities were no longer produced in one place, but instead across space. The global restructuring of the economy, and the coming into being of containerization and just-in-time production, made it possible for capital to seek out the lowest wages in the world and play workers off against each other, dispersing proletarian resistance.

As port police officer Beatrice "Beadie" Russell says in the second season of *The Wire*, which takes place in the port of Baltimore among laid-off dockworkers and corrupt port authorities: "World just keeps turning, right? You guys move on to something new. No one looks back."[18] The period from the middle of the 1970s has been one long crushing of workers and unions, and the container has played its part in this development.

Logistics as capital on speed

Intermodal transport and just-in-time production together constitute what is commonly referred to as "the logistics revolution". Logistics is the ability to control the flows of commodities. It is the science of organizing the turnover of capital to maximize efficiencies of transport, communication and distribution. This has, of course, always been important in capitalism, but with the arrival of the container, and the creation of a global network of production and assembly in which components, commodities, workers and consumers move, the lines between production and distribution have been

further blurred. In contemporary capitalism, technologies of coordination and distribution are of the utmost importance, to such an extent that we can almost speak of a reversal of the classical economy in which labour and production were at the heart of things.

Today, it is purchasing power and distribution that drive the economy. Or, more precisely, we can say that logistics blurs the borders between production, distribution and information, or synchronizes streams of production, distribution and information, with a view to optimizing not just the speed, but also the choreography of commodity flows. Hadid's BMW plant is a spectacular expression of this dream. It is a dream of somehow being able to surpass the mode of production by transforming all fixed capital into circulating capital, producing "ultimate profit machines".

Logistics has a long military pre-history, which goes back several centuries or even millennia. Initially, logistics was the ability to supply an army in enemy territory with weapons, materials, food and medicine without slowing down the movement of the army. It was the knowledge of where to stock material and how much to stock, providing support and shelter for the troops. "An army marches on its stomach," as Napoleon allegedly said.[19]

In the 19th century, logistics was theorized as the third fundamental element of military operations after tactics (the act of making decisions during a battle) and strategy (high-level and long-term planning to secure victory). Logistics was the ability not only to sustain military campaigns in enemy territory, but also to target enemy supply chains. It is only fairly recently that logistics has become an industry in its own right, with companies devoted to handling the administration of shipping, and as a new paradigm for capitalist development, becoming more important than production.

Spurred on by Cold War military research into cybernetics

and operations theory, logistics started moving into the business environment in the 1970s, but only acquired the scope of a paradigm a decade later. Today, the field of logistics has expanded and conquered not only engineering, but also business studies, management research and policy studies, and is making its presence felt within fields such as philosophy and neuroscience.

The origin of logistics as the practical art of moving armies shows that it is not just about moving stuff, but also concerns the art of sustaining or ending life. In the literature of logistics, it is often conceptualized as a life system in itself, described in biological terms of "survival" and "resilience", and the ability to protect movement against threats. This biopolitical dimension of logistics, which has always been present in its military and paramilitary definition, is also present in the new expanded conception of logistics.

As Stefano Harney and Fred Moten wrote, logistics almost seems to have taken on a life of its own. Supply chains and circulation not only need to be protected, but also to become life itself, the life of trade. This is the culmination of the explosive development of logistics, in which flow and movement are everything. "Traditionally strategy led and logistics followed. Battle plans dictated supply lines. No more. Strategy […] is today increasingly reduced to collateral damage in the drive of logistics for dominance."[20]

As geographer Deborah Cowen has argued, the entanglement of military and economic force is still key to logistics, and the new logistic paradigm that has spread to a range of other fields like business, management and philosophy should be conceptualized as a kind of war. Today, this primarily means war by trade, with the circulatory flows of goods being used to pit workers against each other, increasing the competition for scarce jobs, driving down wages, and exploiting wage differentials between core and periphery in the world economy.[21]

In a longer historical perspective, logistics is an attempt to manage or find a way out of the overproduction and resulting falling rate of profit that occurred in the late 1960s and early 1970s in the dominant economies. Capital is prone to crises of overproduction and logistics is part of the restructuring that has taken place since the early 1970s, as capital has tried to save on social reproduction, excluding workers from capital's metabolism. Logistics is a desperate attempt to cut back on expenses, a hectic search for low costs. Thanks to the intermodal transport system and new telecommunications, capital responded to the protests of the late 1960s by globalizing production, disbanding workers in the West and preventing a revolutionary alternative from materializing.[22] A global labour market was established, in which cheap labour in Asia, and parts of Latin America and North Africa, put pressure on workers in the old centres of accumulation, forcing them into different and more precarious forms of labour.

This is the structural and invisible violence of capitalist accumulation, but as Cowen makes clear, logistics is also related to war and violence in a more visible and concrete way. This is because capital and states have an urgent need to protect their supply lines, from fighting pirates in the Gulf of Aden to scanning containers for bombs. New paradigms of security have come into being during this development, all aimed at keeping the likely disruptions to the supply chain at bay.

Threats to the just-in-time transport systems lie everywhere, from bad weather to flat tyres, failed engines to road closures, national borders to pirates and striking workers. All represent serious damage to the system and thus not only require regulation, but also often need to be violently erased. As a consequence, "corporate and military logistics is increasingly entangled", as Cowen writes.[23]

Supply chain security is a central aspect of the current state of emergency in which goods, executives and workers need to cross

borders at ever higher speeds, while migrants and terrorists need to be prevented from moving anywhere, at all. "Today capitalist globalization at once creates a single global order and constantly divides it through multiple and shifting practices of bordering."[24]

This is a development in which the distinction between military and police tends to disappear, as Michael Hardt and Antonio Negri write, in which armed conflicts are administered and represented as police actions both within and beyond the borders of the nation state. "War is becoming a general phenomenon, global and interminable."[25] In the form of logistics, war has become a permanent social relation, fusing exploitation and domination in new ways. "Logistics space is produced through the intensification of both capital circulation and organized violence."[26] As the Invisible Committee writes: "Contemporary power has made itself the heir, on the one hand, of the old science of policing, which consists in looking after 'the well-being and security of the citizens', and, on the other, of the logistic science of militaries, the 'art of moving armies', having become an art of maintaining communication networks and ensuring strategic mobility."[27]

If the creation of global supply chains was an attempt to get rid of the rebellious workers in the West by replacing them with more docile and much cheaper workers elsewhere (logistics and finance as fantasies of smoothing out the world by eliminating friction and resistance), it was also an impossible dream of getting rid of wage labour altogether, as if it were possible to create value without living labour, without putting workers to work. In this sense, logistics or integrated distribution management takes on the form of something much more ambitious. It becomes an attempt to remove wage labour and the proletariat from the capital-labour relation that constitutes capital in the first place. It is a fantasy of capital without workers. As Moten and Harney write, "Logistics wants to dispense with the subject altogether.

This is the dream of this newly dominant capitalist science."[28]

In the logistic phase of capital, workers are always redundant, as if it will always be possible for capital to find cheaper workers elsewhere who are quite able to do the same work: from France to South Korea to China to Ethiopia and onwards, on the path to total automation. But as Marx stresses at several points in *Capital*, labour is essential to the valorization of capital. Capital not only risks underconsumption or social unrest, but it is also slowly digging its own grave by trying to free the flow of goods from "human error".

The restructuring of capital, containerization, outsourcing and finance represent the exclusion of more and more people from the circuits of capital. People are not only deskilled as precarious labour, but they are also simply disqualified or excluded. Billions are being transformed into what Michael Denning terms "wageless lives", forced to seek to survive on the margins of the capitalist production process, making do with whatever they can get their hands on.[29] As Endnotes writes:

> ... for a huge chunk of the world's population it has become impossible to deny the abundant evidence of the catastrophe. Any question of the absorption of this surplus humanity has been put to rest. It exists now only to be managed: segregated into prisons, marginalised in ghettos and camps, disciplined by the police, and annihilated by war.[30]

Capital is eating itself, and leading billions to a fate of misery and death. This is the other side of Hadid's BMW plant in Leipzig. The uneven development of capital has, on the one hand, created a complex structure with experimental and spectacular architecture, which seems to defy the logic of building materials, showcasing flexible production without hierarchies, while on the other hand producing absolute immiseration, an underworld of exclusion and slums, uprooting people from their pre-capitalist

conditions and preventing them from entering the capitalist production process, forever unable to buy the new BMW 3 Series or even to enter the factory. The result is a complex geography of post-liberal logistic hubs, with BMW, Amazon and DHL side by side—as is the case in Leipzig, where the city has sought to overcome a period of urban decline by making it "favourable" to logistics companies by investing in the airport and in highways—intermixed with zones of post-development and misery.[31]

Exit: Reconfiguration or sabotage

There has recently been discussion of possible communist repurposing of capitalist production in the age of logistics. In the final pages of *Valences of the Dialectic*, Fredric Jameson asks what it would mean to take over Wal-Mart's supply chains as part of a socialist revolution. Wal-Mart is, of course, the world's largest retail chain, with nearly 11,000 stores importing 700,000 40-foot containers per year from China, where 91 per cent of its products are made. Wal-Mart is one of the largest businesses in the world, with earnings that would make it the 27th most powerful nation were we to translate its earnings into GDP.

Wal-Mart has been the object of numerous criticisms: it is anti-union and barely pays a living wage, and it hires illegal immigrants and promotes child labour (outside the US). But in accordance with his use of dialectics—famously reading *Jaws* as both confirming the existing social order and pointing beyond it, with a utopian dimension—Jameson goes looking for Wal-Mart's utopian potential, asking what use logistical networks could be put to in a post-capitalist world, so "that what is currently negative can also be imagined as positive in that immense changing of the valences which is the Utopian future."[32]

With Wal-Mart, "the anarchy of capitalism and the market has been overcome and the necessities of life have been provided for an increasingly desperate and impoverished public." As such, Wal-Mart is "a model of distribution", Jameson provocatively

writes.[33] According to Jameson, Wal-Mart is already somehow transforming free-market capitalism into something different through its enormous apparatus of circulation and consumer surveillance. Wal-Mart might just happen to be Marx's negation of the negation, abolishing the market through the market.

If Jameson is trying to argue for a redeployment of capitalist logistics, others argue that this is impossible, that a repurposing of logistics will perhaps mean a transformation from the current accumulation regime, but not an end to capitalism.[34] Supply chains and logistics as a paradigm have to go. The vast systems of dead labour that capital has erected around us cannot be put to different use: we cannot negate the negation but must destroy it.

The whole apparatus needs to be torn down. It is a matter of rendering useless, not of redeploying. It is a system in which each component is designed precisely to extract surplus value, an infrastructure of hostility and exclusion that is not appropriable for proletarians. But no matter what position is the right one—sabotage and interruption versus attempts to repurpose supply chains—this is the field on which any serious analysis of contemporary, late-capitalist society has to begin. As for architecture, Tafuri was probably not that far off the mark when he concluded that architecture inevitably always ends up serving what he, in straightforward Marxist terms, called counter-revolutionary ends, crushing potentialities and erecting a world of limited possibilities—architecture as one of capital's most important means of negating social space.

Chapter 6

Imagining a Future

"The horror is that for the first time we live in a world in which we can no longer imagine a better one."[1]
Theodor W. Adorno

In his 2012 article "For a Left with no Future" published in *New Left Review*, T.J. Clark engages in a critique of the European Left's avant-gardism, and its century-long ideas of progress, redemption and emancipated futures.[2] According to Clark, the Left has for a long time—always?—been enamoured with a problematic notion of the future, where the Left spends most of its time coming up with "fantastical predictions about capitalism's coming to an end".[3] The Left has been imagining a whole arsenal of different endings, envisioning coming insurrections to sweep away capitalism in all-out revolution or looking for signs of the soon-to-come crisis—a point of no return, destroying the capitalist mode of production, setting the enchained workers free. Endings, as well as beginnings, of course—the different beginnings of the many and diverse socialisms or communisms, from the production of a new world with heavy industry and tractors—"All efforts to attain the goal of eight million tons of grain"—to a return to a blissful (primitive) communist Eden or the introduction of the notorious "dictatorship of the proletariat" in its different guises, some more militarized than others.

We know the images and representations that intellectually run from Marx's "hunt in the morning, fish in the afternoon, rear cattle in the evening, criticise after dinner", through Gramsci's Fordist fantasies, to Hardt and Negri's ever-creative and networked multitude that has already made capital's dialectical mediation obsolete. Though, to state the obvious,

they may differ—there's quite a difference between the Soviet "utopia of production", as Buck-Morss calls it, and the Parisian students' desire to reveal a beach beneath the pavement in May 1968—they all, according to Clark, share the same avant-garde modernist tonality, the same language of infinite possibility, the sense of a future to be realized, a present to be overcome.[4] Clark wants to break free of these visions of progress or crisis. "Leaving behind, that is, in the whole grain and frame of its self-conception, that last afterthoughts and images of the avant-garde."[5] And this is not only because these visions turned out to be prone to extremely violent political practices in the period from 1917 to 1989, and were never able to mount a real challenge to capitalism anyway, but also because they prevent the Left from coming to terms with the present situation of defeat.

The Left needs to wake up from the 20th century, Clark writes. The Left needs to bid farewell to the grandiose programmes and radical schemes of the 20th century. It is hanging on to the remains of an apocalyptic imagery. As Clark puts it: "Left politics is immobilized, it seems to me, at the level of theory and therefore of practice, by the idea that it should spend its time turning over the entrails of the present for signs of catastrophe and salvation."[6]

As the title makes crystal clear, Clark is seeking to distance himself from what he perceives as the overriding theme and tonality—the *Stimmung*—of a Left obsessed with the future or strangely seduced by the possibilities of modernity, and totally blind to its extreme consequences. According to Clark, the Left has been strangely mesmerized and repulsed by capitalism, and the possibilities it brings into being, simultaneously. And he is right, of course. Take Marx and Engels in *The Communist Manifesto*, where they sing the praises of the bourgeoisie's destruction of previous forms of solidarity and modes of production, all the while promising/hoping that the proletariat will realize what the bourgeoisie has been unable to accomplish.[7]

There is no doubt the Left has been fascinated by such images and painted endless versions of it throughout the last two centuries. The Left so often turned out to be a horrid inversion of capital's own modernizing terror, as part and parcel of the capitalist modernity it half opposed, half embodied. The Left failed. It always ended up defeating itself and stood every time, when it came down to it, too close to the worldview of its opponent, capitalism.

The need to accelerate the destruction of capitalism has been a steady feature in Left thinking and practice, to a point where the Left turned out to be the realization of the nightmare of the new world, where people became a material to be moulded and given form. Focusing on the end, the means became less important and the glorious future ended up legitimizing one horror after another. The Left ended up negating the brute fact of existence—forgetting the fact that this world is the only one we will ever have.

Clark's critique is, in many regards, right on the money. But in an odd doubling of his own critique of the Left's inability to see nuances—Left, socialism, communism, the terms tend to flow together in sweeping judgments—Clark takes no prisoners and his conclusions are pretty stark, bordering on dead-hard anti-communist totalitarianism: the way to socialism was indistinguishable from, or simply just was, one big tragedy from the Gulag to the Killing Fields. The Left's grandiose schemes and gigantic programmes paved the way for an unfathomable terror. Apocalyptic Left and apocalyptic Right thus converge in Clark's analysis: "Socialism became National Socialism, Communism became Stalinism, modernity morphed into crisis and crash."[8] "A false future," Clark calls it.

Instead, Clark opts for what he, following Nietzsche, terms "the most modest, most moderate, of materialisms".[9] This being a substitution of most of Marxism, with a highly selective and particular mix of Weber, Nietzsche, and other conservative

thinkers and tragedy-theoreticians. Clark conceptualizes this as a move away from avant-gardist obsession with everything young and rebellious towards a "mature" and "grown-up" — these are Clark's words — politics, which would understand and hold at bay the human drive for violence.

The Left's utopian orientation has tragically been blind to or even paved the way for the deep-seated "human propensity to violence", Clark writes, building part of his attack on the Left's emancipatory (read: violent) politics on a quasi-anthropological argument about human nature's inherent drive towards violence and "the horror and danger built into human affairs", referencing Walter Burkert's thrilling *Homo Necans*.[10] Violence is a constant presence in human life, but the Left has failed to realize that.

After "the Century of Violence", the Left has to rebuild itself in order to prevent "the tiger [of violence and war] from charging out", Clark writes, urging the Left to recognize the presence of violence in all human endeavours. Recognizing that there was no final cause to explain the barbarism of "the age of human smoke", as Clark calls the 20th century, invoking, or outdoing, both Nicholson Baker's dark *Human Smoke: The Beginning of World War Two, The End of Civilization* and Mark Mazower's already pretty gloomy *Dark Continent*.

Clark wants the Left to modulate its notion of human possibility and history into something he calls "a tragic key". He wants them to give up the idea that revolution would somehow resolve the contradictions of the past and the present. This is the "moderation" he is asking for. Leaving the extremes and giving up on optimism. Nietzsche's "pessimism of strength": a sense of the limits to human affairs, a pessimism that is also a pragmatism, a politics without illusions, truly pessimistic and worldly. Finally understanding that the revolution will not be the realization of some historical logic. A realist Left that renounces all-or-nothing visions of building a new world. A downscaling of the project of the Left or a substitution of its

radical utopianism with a tragic pessimism more in tune with modernity's horror. Understanding that there will be no peace, that we are faced with the prospect of permanent war.

So, Clark wants the Left in the capitalist heartland to give up on the future in favour of the present. To give up on the big revolutionary ideals in favour of a quieter, more concrete and "actual" approach. Ditching the visions and idioms of futurity — the otherworldliness that is part and parcel of the revolutionary project. A politics of moderacy, a politics of small steps: "It [...] is wrong to assume that moderacy in politics, if we mean by this a politics of small steps, bleak wisdom, concrete proposals, disdain for grand promises, a sense of the hardness of even the least 'improvement', is not revolutionary—assuming this last word has any descriptive force left."[11]

Clark is absolutely right: from Marx to Diamat, we find problematic notions of historical development that were, no doubt, put into practice in highly unfortunate ways and legitimized brutal regimes. But does that mean that we have to give up on the idea of revolution? For that ultimately seems to be Clark's solution to the problem: renouncing the revolution. That is the meaning of the attempt to keep the Left but giving up on the future. Clark is giving up on radical change, as this has shown itself to be a straight road to hell on earth, but he wants to preserve and reform the Left. Preserving the Left but renouncing the revolution.

In many ways, I think Clark is right in engaging in a ruthless critique of the euro-modernist Left and its future-oriented stance. His intervention is a hugely important contribution to the necessary critique of the assumptions and premises of radical political practice, and the rhetoric of the European Left today. Clark wants to do away with both wishful thinking à la post-*autonomia*'s ideas of the multitude, as well as automatic notions of capital's decadence. And there is much in Clark's attempt to substitute a leftist critical theory with a leftist tragic theory that

is convincing and much needed. No doubt, but I nevertheless remain somewhat sceptical. Clark seems to be willing to let go of an awful lot in his attempt to revise the Left. And I'm not sure it's the right things he is bidding farewell to.

Although there is, of course, a reference to punk in the title, Clark quickly moves from punk to resignation. From the Sex Pistols to Nietzsche. The Left has to put adolescence behind it, Clark argues. But does no more programmes mean giving up on critique of the capitalist system and turning inwards, contemplating old prints and lamentations over failed revolts?

Fighting the eternal present of the spectacle by returning to a cultural heritage that promises contact with a lost world—Clark urges his readers to substitute reading *The Coming Insurrection* with Christopher Hill's *The Experience of Defeat*—looks a lot like the reverse image of "the present age of ardent, fetishistic 'memorialism'".[12] Could a farewell to programmes not mean being engaged in radical self-critique, as has been the case many times before? As Clark himself has shown in an earlier rebuttal to Fred Jameson and Perry Anderson, the present conditions of impossibility were already a cultural fact much earlier in the 20th century. They also confronted Luxemburg, Korsch, Debord, etc., with tremendous challenges in their times.[13]

The ending has been going on for a long time now, we might say. In that sense, the Left has been without a future for a long time. That's the challenge in a way, how to engage in an all-encompassing critique of capitalist society without formulating visions of a much better tomorrow and without plans for how to run the capitalist economy differently (as the Social Democratic and Leninist Left tried to do in vain). That was already the task revolutionaries like Naville, Bataille, Benjamin—or later Jorn or Debord—set for themselves: a total transformation of everyday life. That was previously the task for this kind of "dark Marxism". The solution is not giving up on anti-capitalist struggle, as Clark seems to be proposing. The solution is giving up on the Left,

ditching the identity and the project of the Left, it seems to me. Not downscaling and turning backwards, but upping the ante in order to create a different future.

It's simply just not the right opposition Clark is operating with, and it might just be time to exit the closed interiors of the political struggle of Left and Right. It is time to move beyond democracy as we know it. Political democracy and the whole Left-Right debacle do not make much sense when we are dealing with the question of revolution (and counter-revolution). The Left-Right opposition has, from the very start, distorted the potentials of the revolutionary break. A revolution is simply a confrontation of a different nature than the political conflicts between Left and Right. The revolution is the production of communism; in other words, a real break with the bourgeois nation state and the complete abolishment of capitalist social relations (wage, money, etc.).

The Left has, of course, made references to revolution throughout the 20th century; Stalinists, Trotskyists, Maoists, Guevarists and New Leftists have used the term, but so have fascists and Islamists. And we all know the mechanism of political democracy, in which the Left-Right opposition is a key ingredient: to prevent any kind of radical change, balance out the seeming struggle between Left and Right parties mediating the class struggle, and keep it confined to the nation state.

The Left-Right political spectrum is a huge problem for the revolutionary perspective and does not make any sense. It never did. Clark's text testifies to that. It became particularly clear when the European social democratic parties turned neo-liberal, but it was already pretty clear to Luxemburg in 1914 and Debord in the 1960s. Clark seems to be on the verge of realizing it in his text—"Left, then, is a term denoting an absence"—but he prefers to keep the term, emptying it of all revolutionary content.[14] But we need to get rid of it. Get rid of the Left.

In daily life, we pretend to know what the distinction

between Left and Right means, when in fact it has no logical signification whatsoever. The historical origin of the distinction between Left and Right goes back to September 1789, when a Parisian paper first used it to describe opposed fractions in the National Assembly. To the left of the president's chair in the Assembly gathered the opponents of the monarchy and to the right the king's supporters. Traditionally, the place of honour in the *Assemblée* was on the right of the president and this place belonged to the aristocracy. The division of the political sphere into Left and Right thus came into place: the Right being the ones who wanted to maintain the status quo, while the ones on the Left were in favour of change. If the National Assembly had been arranged the other way around, we would be labelling Luxemburg, Bordiga, Rühle and Gorter "ultra-rightists".

The way the Left-Right division is used distorts capitalist society and creates political sympathies that are based on unconscious political reflexes alone. The actual political effect of this dichotomy in Western Europe is, more often than not, a surprisingly equal division between those voting Left and Right. This is not the effect of a corresponding uniformity in the social constitution of these states; it is instead caused by the manifestation of the Left-Right model's purely mathematical logic.

The figure produces a polarization of the population, which cuts across social groupings. The population is split into two more or less equal political groups that are opposed to each other by definition. The polarization inherent in the Left-Right dichotomy "naturally" privileges the centre (and political compromise). The problem is, of course, that the capitalist mode of production is anything but moderate! It is radical, in the sense of going to the core of things. Life in the most basic sense—people and the biosphere—is being threatened by the logic of capital accumulation. The solution ought to be as radical—the negation of the capitalist system—definitely not moderate, as

Clarks argues.

The Left-Right dichotomy Clark subscribes to actually prevents the development of this radical project. Within the Left-Right political spectrum, radicalism and the revolutionary perspective take on the form of "extremism", which is loaded with negative associations, and is portrayed as blind passion and terror; "Pol Pot", Clark writes. People on the Left are thus afraid to go to the extreme, to step outside the normal cosy political spectrum and end up standing alone. The abolition of the capitalist system is thus abandoned. The revolutionary perspective—the overcoming of capitalism as the abolishing of wage labour and the state—disappears.

The fear of extremism functions as a deterrent to thinking matters through. The result is that the Left functions as a guarantee for the continuation of current "political" thinking. Therefore, the important distinction is not one between Left and Right, but between being for or against the revolution as the abolition of capitalism.

When we are dealing with the revolution we are dealing with a philosophical and anthropological question that has to do with promise. Not because we have to raise hopes, somehow, but rather as an attempt to install some kind of trust, showing that revolution is better than decline and decadence.

But the necessary working through of the Left does not take place, as Clark prefers to lump together everything from Stalinism to ultra-leftism as instances of an avant-gardist Left. But Clark should readjust his aim—it is less the avant-garde than the Left that is a problem. It is time to leave behind the project and identity of the Left altogether.

Unfortunately, Clark never goes that far, preferring to critique what he considers the damaging avant-gardist dimension of the revolutionary project. But the inability to engage in a critique of the Left, all the while dismissing the revolutionary perspective, means Clark ends up in some kind of nihilist left-leaning

conservatism, where he warns about the continued presence of violence and war. The critique of the disastrous consequences of revolutionary transgression comes dangerously close to an anti-totalitarian position that has characterized the fight for another world as violently excessive and doomed to failure ever since the Russian Revolution. Clark is on the brink of joining an odd choir of reaction, where he not only sits uncomfortably with the likes of Jacob L. Talmon and Hannah Arendt, but also François Furet, Martin Malia and André Glucksmann.[15] Strange bedfellows for the former situationist.[16]

In the present situation, ditching the distinction between reform and revolution comes across as somewhat strange. No doubt the Arab revolts and the movements of the square have been unable to set off a successful global wave of revolutionary protest, and have met with serious opposition. Nevertheless, they do constitute the most important resistance to the present capitalist system for 40 years.

Not recognizing the potential in the recent upswing in protests, strikes and demonstrations gives Clark's text a peculiar semi-aristocratic tonality not that different from his friend/ enemy Perry Anderson, who also withdrew decades ago to some kind of intellectual Olympus, from where they dismiss any and all protests: "Oh dear, the natives are restless." By foregoing distinctions between revolution and reformism, as well as the distinction between revolution and counter-revolution, Clark risks ending up not only with no future, but also and more importantly with no revolutionary position from which to engage in any kind of meaningful critique of capitalism, besides a moralizing lamentation of its hollowing of the human.

Part of the problem with Clark's analysis is precisely his move away from a Marxist framework towards a Weberian one, where capital is replaced with modernity as an iron cage and where the vocabulary centres on the emptying out of meaning, where disenchantment becomes the central process of modernity rather

than the accumulation of capital.[17] As Clark has left behind the critique of political economy, he is left with a language of loss and privation. We are stuck with a gloomy quasi-sociological account of the destruction of some prior world of communal values and life forms as a result of rationalization and disenchantment.

This also comes out in his dismissal of what he sees as attempts to pinpoint any single reason behind the horrors of the 20th century. The tragic perspective "allows us *not* to see a shape or logic [...] to the last hundred years."[18] So there is no attempt to find a cause for the chaos. We should give up trying to give shape or form to the catastrophe. The Left is inevitably going to end up empty-handed. It is not possible to revert the process or take control of it—that will only further escalate the destruction, according to Clark's verdict. No escape, no compensation, but a wasteland of meaninglessness. Revolutionary programmes and tragic formlessness become inseparable. Nina Power has aptly described this as a kind of "Left Burkeanism" (no more future, no more bold novelty and no more dramatic metaphysical principles).[19]

In the end, Clark's ends up looking a lot like a disillusioned post-revolutionary enterprise, left with nothing but melancholic reformism bordering on the reactionary. It is quite telling that he urges the Greek Left to come up with a "persuasive" plan of how to proceed—"a year-by-year vision of what would be involved in taking 'the Argentine Road'".[20] But that would no doubt only amount to yet another attempt at squeezing out relative surplus value. And that has nothing to do with revolution and the abolition of capital. It would just be state capitalism anno 2015.

The trajectory of SYRIZA, not yet clear when Clark wrote his text, is unfortunately very revealing for such a strategy. Despite its "anti-authoritarian" rhetoric, SYRIZA has quickly shown itself to be a pillar of the system, protecting the interests of capital and contributing to the preservation of the authority of the bourgeois state. This might be described as leftist, but it's

the Left of capital.

Clark's necessary critique of the euro-modernist Left stops short of, and foregoes, the possibility of leaving the Left in favour of a problematic return to a politics of "small steps", disconnected from any idea of an anti-capitalist movement. His vivid description of the total breakdown of the Left is in many regards spot on, but the attempt to leave Marxism in favour of some kind of tragic Weber/Nietzsche-inspired position goes awfully wrong.

Clark rightly points to the strange fact that reformism no longer seems possible. That in the capitalist heartland, reformist demands today almost take on the form of impossible revolutionary demands. But he fails to historicize the reasons for this, preferring instead to advocate a "moderate" and "grown-up" reformist project along the lines of the Committee of 100. However, it is not because the reformist Left has somehow become revolutionary or because the distinction no longer matters. It is instead because the reformist position is no longer possible. The conditions of possibility for a reformist social democratic, as well as a reformist Leninist strategy, have simply withered away.

The restructuring of the global capitalist economy that has been going on for the last 40 years—outsourcing to South East Asia and parts of Africa thanks to new technologies (computer and container hand in hand), and the smashing of the previous strongholds of militant working-class resistance, plus the introduction of credit and the rise of finance capital— has effectively pulled the rug from under the working-class composition that made these models possible in the first place. That's the real meaning of "no future": a whole generation of people across the globe have become redundant to capital and the euro-modernist working-class movement's project of taking over the apparatus of production no longer makes sense. We are living through a transformation in relation to exploitation,

tending towards the exclusion of more and more people from the extraction of surplus value, hollowing out the "programmatic" and reformist Left politics of the 20th century.[21]

Workers across the globe are confronted with an objective limit in which their class belonging has somehow become external and can no longer constitute a point of departure for a political project. That's why reformism is no longer possible. Class struggle has taken on a new form and can no longer be a "making of the working class: Thus the era of the Left—the period in which the EU and US working class could somehow struggle inside the capitalist system—is quickly coming to an end.

As Clark himself puts it: "[I]f the past decade isn't proof of that there are no circumstances capable of reviving the Left in its 19th and 20th century form. Then what would proof be like?"[22] Indeed. Let it go, there's nothing left of the Left. But that does not mean the revolutionary perspective has disappeared. The revolution will not be, and in fact never was, "leftist"; time will tell if it will make sense to call it "socialist" or "communist".

A New Beginning

In 1963, the situationist Michèle Bernstein made a series of paintings called "Victories of the Proletariat", where she engaged in a kind of counter-factual history painting, imagining that the Paris Commune and the Spanish Republicans had won. What if the proletariat had indeed prevailed in 1871 in Paris? Bernstein asked. If they had been able to hold the French army at bay and had finally seized the National Bank. If the experiment had not ended after 72 days, but been allowed to develop and expand. Or if the Spanish anarcho-syndicalist workers had managed to defend the revolution against domestic and international counter-revolution, and even extend it. Or if they had actually won the Spanish Civil War and beaten Franco, as well as the Stalinist and social democratic forces, which not

only undermined, but also eliminated POUM, and the other revolutionary groups and parties. Where Clark takes leave of imagining a different future and prefers to engage in a kind of backwards-looking non-utopian reformist activity, thereby creating a kind of retracted "political" space, Bernstein was engaged in imagining a communist future through a different past.

Bernstein's paintings were part of a strange exhibition, where the SI tried to engage in a tricky and complicated endeavour. They sought to reconnect a new revolutionary offensive with past failed revolutionary experiments. By imagining a past that could have been different, they sought to imagine a different future, a non-capitalist and communist future. Imagine the end of the spectacle.

"Victories of the Proletariat" was part of an exhibition titled "Destruction of RSG-6" that took place in a small squat in Odense in Denmark, called Huset (The House). The squat was the headquarters of the local CND, and was a hangout for a large group of misfit Danish youths and self-proclaimed socialists critical of both the booming Western capitalist societies with their new commodity-based identities and the Soviet party dictatorship. The youngsters were trying to find an alternative position beyond the self-confirming binary of the Cold War and they engaged in a series of activities, including campaigning against the rise in Danish tourism to Franco's Spain.

The squat was thus an ideal setting in a Scandinavian context for the situationists, who wanted to counter the Bauhaus situationist movement. It was run by former member Jørgen Nash, who was busy staging provocative stunts that both outraged and entertained the Scandinavian public. The situationists had to make sure people knew Nash was not a situationist and did not express the project of the SI. This was not some kind of ludic here-and-now art activism, but a thoroughgoing revolutionary critique of capitalist society, and its means of control and

domination, including the state, wage labour and money.

The situationists' use of the small gallery in the basement of the squat in Odense was risky business, and the situationists tried in different ways to make explicit their indifference to the dominant aesthetic standards and highlight their dismissal of the art world. "Destruction of RSG-6" was not an ordinary art exhibition, but was conceived as a revolutionary use of an occupied territory; according to Bernstein, Debord and the situationists, the art world now functioned as a safety valve, where seemingly critical gestures were exhibited to little or no effect. The individual artwork could only express a formal pseudo-liberty and it was thus necessary to leave behind art.

According to the situationists who subscribed to a kind of Hegelian Marxism, where the proletariat was the historical subject who put pressure on the world and especially on the way the world was to be interpreted, the historical development had made the artwork obsolete. It was destined either to fuse with the established taste, what the situationists termed recuperation, or leave art behind in favour of an expanded artistic critique outside the institution of art. It was simply no longer possible to create individual artworks with an individual signature and author.

In order to be true to the genuinely transgressive nature of modern art from Rimbaud to Breton, it was necessary to ditch not only the cultural establishment, but the role of the artist as well, foregoing poetry and painting in favour of overcoming art. In Hegelian terms, art had to be suppressed and realized in revolutionary theory and practice. This is the kind of all-or-nothing approach that Clark has difficulties with. Confronted with the overwhelming defeat of the Left, he prefers to hold on to the few remaining places of resistance. For the situationists, on the other hand, this amounts to complete surrender.

The situationist position on art had become especially clear during heated debates within their numbers in 1961 and 1962,

where more or less all artists left, or were expelled from, the group and where it was decided to label all artworks made by situationists "anti-situationist".[23] The event in Odense was thus not in any ordinary sense an art exhibition, but was intended as what the situationists termed "a manifestation". Here, they would use the gallery in the squat's cellar to make clear the situationist analysis of the historical situation and to intervene in an ongoing discussion about the threat of a nuclear war, and the way the threat was being used by the ruling elites in Western society.[24]

One and a half months prior to the opening of "Destruction of RSG-6", British anti-war activists had revealed secret plans to hide the British government in case of war. They had discovered and revealed the existence of a series of secret bunkers, where officials were to seek shelter in case of nuclear attack.[25] The situationists had already analysed this politics of fear in articles in their journal *Internationale situationniste*. In it, they critiqued how the threat of nuclear war was being used both to reduce politics to a question of being against a dangerous communist Soviet Union (and thus unquestionably for the West and the leaders of the West), as well as create a whole new series of nuclear-war commodities like the family shelter.[26]

The function of the accelerating Cold War nuclear arms race was to deter not the enemy, but the state's own population, the situationists argued in an attempt to convince the CND movement. This movement was gaining momentum at this time in a number of Western European countries, to expand their critique rather than just focus on the threat of annihilation.

The real risk was the silencing of critique. It was important to connect the anti-nuclear position to a radical critique of capitalism. Remaining within the spectre of annihilation would only serve the interests of the existing political and economic forces, the situationists warned. Any kind of limited anti-war stance, like the one Clark is now advocating, was not enough,

the situationists argued.

The manifestation in Odense was thus a continuation of this critique, combining it with a critique of modern art's inability to come up with anything new; in other words, Nash's silly pseudo-critique. In order to confront the audience with the bleak future of nuclear war—the threat of nuclear annihilation— the situationists transformed one room of the exhibition into a shelter with plank beds and sirens. This was risky business, as it was dangerously close to subscribing to the politics of fear that the situationists were critiquing. It was an experiment in testing the ruling representations, trying to subvert them and using them in an attempt to present the situationists' analysis.

In order to move beyond the doom and passivity of the shelter, the audience was led into the next room, where they were supposed to become active participants in the critique of the politics of fear. In this room, the situationists had hung a series of targets attached with photos of politicians, enabling the audience to react by firing airguns at the leaders of the Cold War: Kennedy, Khrushchev, Adenauer, de Gaulle, etc. The manifestation also included a series of small slogan paintings by Debord, with phrases from the revolutionary tradition like "The Realisation of Philosophy" and "Abolition of Alienated Labour". The latter was written across a painting by former SI member Pinot Gallizio, putting the painting into use as a blotting pad for quick propaganda scribblings.

The artwork was to be put to use in the struggle against the new means of control of commodity society. If Debord's small word paintings called "Directives" outlined in catchphrases, the contours of the project of the SI—J.V. Martin's contribution, the Danish member responsible for setting up the exhibition—was a further dramatization of the doom-ridden prospect of the present world. In a series of large paintings termed "Thermonuclear Cartographies", Martin painted maps depicting the world after the outbreak of a third world war: "On the second day they say

there will be 82 mega-corpses." Next to Martin's maps of a bomb-struck world, Bernstein's so-called "Victories of the Proletariat" were installed.

There were three pictures by Bernstein in the show: "Victory of the Commune of Paris", "Victory of the Spanish Republicans" and "Victory of the Great Jacquerie". Bernstein's pictures depicted historical battle scenes, where the proletariat had lost to counter-revolutionary forces. In Bernstein's rendering, things were turned upside down and the proletariat suddenly emerged as the victor.

On a formal level, the paintings were just as unpretentious or hastily made as Debord's signs and Martin's maps, being made with plaster, with toy soldiers or plastic tanks pressed into the surface and paint splashed on top. As such, they had the look of three-dimensional kindergarten objects, but that was, of course, not unlike other contemporary artworks, like those that artists associated with the *Nouveaux Réalisme* group were producing at the time.

Artists like Niki de Saint-Phalle and Arman were also using toys and other low-culture objects in their artworks. But, where there was a kind of uneasy fascination associated with the new consumer objects in the works by the *Nouveaux Réalisme* artists, Bernstein's "Victories of the Proletariat" were intended as a radical dismissal of the present order of things. It was not a question of some kind of aesthetic or "plastic" quality, but of the effect or impact of creative expression.

When it worked, art became part of a collective historical practice that showed that it was impossible to produce anything new *as art and individually*. Instead of individual artworks, which would necessarily be instrumentalized by the spectacle, we have a radical critical distillate—a transgressive effect or subversive impact that is not art, but that is nonetheless similar to the transcendental edification often ascribed to works of modern art.

Ambiguity or depth had to go and were to be replaced

with precise interventions; the avant-garde exposing capitalist society's subsumption of human relations. That was also the meaning of the term "situation"; a constructed situation was the recreation of moments of revolutionary self-consciousness, where art and theory were superseded. Of course, a manifestation in a cellar in Odense could not, in itself, constitute a constructed situation, but the situationists made an attempt. Debord described the project as characterized by "heavy-handedness", and the situationists were well aware of the awkwardness of the exhibited objects and their failure as artworks. They did not engage in a similar display again, not even in Denmark. The difficulties they had trying to combine a critique of modern art and the nuclear politics of fear were almost too big.

If we return to Bernstein's contribution to the manifestation, we have, of course, to acknowledge the same uneasiness that characterized the description of the overall project. How are we to talk about these objects? It is no straightforward task to inscribe Bernstein's paintings in a discussion about monuments. Or, for that matter, to talk about them as paintings or history paintings. Bernstein was not a painter and nor was Debord. Martin was a painter and continued to paint pictures while he was in charge of the situationist project in Scandinavia; although most likely he did so merely in order to survive outside wage labour.

By now, of course, even Debord ended up in the National Library in Paris, but the situationists managed to resist, or prevent, their inclusion in the art institution for quite a long time. Most of the objects used in "Destruction of RSG-6" no longer exist. Some of them went up in smoke in 1965, when a bomb exploded in Martin's house. A couple of Debord's "Directives" still exist and now occasionally tour the world as part of the exhibitions devoted to the SI that are mounted from time to time. But Bernstein's objects no longer exist. And they were not intended as separate artworks. That's pretty clear. The different

elements in the show depended on each other; the mock shelter, Debord's slogans, Martin's maps and Bernstein's battle scenes. They each had a specific function, outlined by Debord in the catalogue.

In "The Situationists and the New Forms of Action in Politics and Art", Debord starts out by stressing the necessity of fusing "an experimental investigation of possible ways of freely constructing everyday life" (the artistic avant-garde) with "the theoretical and practical development of a new revolutionary contestation" (the revolutionary project). Only in so far as these two strands are put together will it be possible to counter the spectacle, he writes. What is needed is what he terms "a general struggle", where artistic experiment ("the construction of situations in life") "is inseparable from the history of the movement striving to fulfil the revolutionary possibilities contained in the present society". Bernstein's objects were part of this extremely ambitious endeavour of surpassing art and politics.

Of course, "Destruction of RSG-6" was not the revolution. The event in Odense was not even really a constructed situation—people were, after all, primarily only shown an image of resistance—but it was nonetheless an attempt to use art and the new protests against the nuclear threat. As such, it was an ambiguous attempt at using art to situationist ends. As Debord writes in the catalogue, "Destruction of RSG-6" was "an immediate action [...] undertaken within the framework that we want to destroy". As such, the situationists used art, but wanted to supersede it.

With their stunt in Odense, the situationists sought to analyse what Debord called in the catalogue to the manifestation "the new forms of action in politics and art", including the Danish and British activists, who were striving to challenge the new mode of production that separated humankind from the capacity to shape and direct history. The manifestation and the presentation

of situationist theory would ideally give the activists "a new language" and just as importantly give them "a new memory".

It was very much a question of history for the situationists. The society of the spectacle was a society that refused history. History had been broken down into isolated sound bites and self-contained images that were disconnected from any kind of historical continuum. The revolutions of the past were completely forgotten. The spectacle was precisely a kind of representative auto-erotics, where there was no historical depth; everything took place in a strange closed universe, where only de Gaulle and Bardot lived on the screen. The situationists sought to break free from this closed image sphere and recreate a historical continuum, reigniting the historical development and handing back self-determination to the proletariat, who was being held hostage in the mesmerizing spectacle. Therefore, it was a question of creating a connection between the present and the past, exposing the continuation between present-day resistance and past challenges to the status quo like the communards in 1871 or the Spanish Republicans in the 1930s.

It was in that sense that the situationists argued they were continuing the project of the interwar avant-garde and the revolutionary tradition. They were trying to reach back in history and reconnect with radical negations past, but in a completely new context that necessitated a complete overhaul of these past projects, "their surpassing". A new revolutionary offensive had to start with the acknowledgement that "the entire revolutionary project in the first three decades of this century" ended in complete "failure".[27] Only on the basis of this understanding would it be possible to resume the revolutionary project.

We are thus confronted with a complex overlapping of present and past radical gestures that did not follow a straight line, but where the demands of yesterday produce a possibility for transcending the present, realizing a different present. In that way, the past exposed a different possible reality. Where Clark

is forced into giving up on the possibility of a revolutionary perspective, confronted with the present impasse of the Left and the seemingly never-ending historical disasters, the situationists desperately keep up the possibility of a radical break with the present.

Bernstein's "Victories of the Proletariat" did just that. Her paintings were alternative memorials, turning history upside down. As Debord writes in the catalogue, the series "corrects the history of the past, rendering it better, more revolutionary, and more successful than it ever was".[28] It engages in an aesthetics of repetition, where Bernstein rewrites historical defeats as victories. And, of course, not just any historical defeats, but ones where there was a massive popular dimension and participation. Nor was it *coup d'état*, like in Russia in 1917, where a small cadre of professional revolutionaries grabbed state power.

In Paris in 1871, a city was turned upside down and taken over by the inhabitants, who engaged in a radical transformative process. And in Catalonia in Spain in 1936 and 1937, a whole region was turned into a self-managed society by workers' factory collectives and peasant collectives. With the three-dimensional plaster models, Bernstein was restoring the possibility of what once was, rendering the possibility anew. She was salvaging past revolutionary negations of the ruling order. Lost battles where counter-revolutionary forces and brutally ended popular social experiments are replayed with toy soldiers and plaster. History is being rewritten and the proletariat comes out as the victor.

This rediscovery of past episodes from the ongoing epic clash between the classes opens for a different view of the present, exposing a new trajectory through history into the present. What if the proletariat had won in 1871 or 1936? History, in the situationists' Hegelian-Marxist perspective, is not only a catalogue of events or the study of the past, but rather something to be made or remade self-consciously. And by imagining 1871 as a victory, Bernstein is directly attacking the spectacle, which

refuses history and prevents people from actively shaping not only their existence, but also history, locking them in a closed eternal present.

In a radical gesture of disavowal, Bernstein opposes this postcard time with a self-conscious creation of history. History is suddenly opened up and what is, is haunted by what might be. This is not a nostalgic gesture, where Bernstein wants to return to the past, but a radical gesture that is explicitly striving to highlight the dialectic of revolution and counter-revolution—a gesture that strives to turn both history and the present into an open-ended battlefield of class war. "Victories of the Proletariat" is not the return of the identical, of the historical facts of the proletarian experiences and defeats. It is the return of the possibility of what was; it is a making the past possible again.

This is "repetition" in the sense outlined by Giorgio Agamben in a short text on Debord's films: "Repetition restores the possibility of what was, renders the possibility anew."[29] Bernstein is engaged in a similar venture, repeating the adventures of Communards and Spanish republicans not as an act of nostalgia (or memory in Pierre Nora's sense), but as an attempt to render the past possible again, one that restores these lost possibilities of anti-capitalist negation. Bernstein's "Victories of the Proletariat" is an act of resistance, resistance against the spectacle and its indisputableness—the spectacle "says nothing more than 'that which appears is good, that which is good appears'"—undoing the closed world of the spectacle, disputing the facts of history. Undoing what exists in a playful, but determined, act of negation and creation, using the debased existing means of cultural expression, refusing the facts in front of her, entering a zone of indeterminacy between the past and the present, a zone of undecidability between the real and the possible, where the past was put back into circulation again, where the Paris Commune and the Spanish republic were all of a sudden replayed by commodity capitalism's own kitschy toy

soldiers.

By showing us the historical defeats of the proletariat as victories, Bernstein makes them possible again. We have the same situation with the same antagonists, yet completely different. The point being that everything is possible, even the horrors of the spectacular commodity society, but also, of course, another world.

Have We Already Won?

What is to be done, then? On the one hand, we have Clark and his refreshingly circumspect and forthright dismissal of the Left's future-oriented conception of history. According to Clark, this has shown itself to be a nightmarish doppelganger of the most brutal forms of capitalist modernization. Clark is to be applauded for confronting the crisis of the Left head-on. The depth of the crisis is visible in every sentence of his text. A previous vocabulary is no longer available and the very temporality of modernity has foundered, leaving only the past as a place of secret resistance.

The breakdown of a whole tradition of leftist thinking and practice is indeed the staring point for any serious discussion of an alternative politics. Clark is right in that respect. The two big competing fronts of the Western working-class movement, social democracy and Leninism, have disappeared. Leninism did not survive the dissolution of the Soviet Union and the social democratic parties in Europe have not had a vision of a better future for a long time. Indeed, they seem utterly unable to develop one after their neo-liberal makeover.

The promise of the Russian revolution is long gone and the Left does not set the agenda any more. Clark's proposal is to develop "a kind of middle vision", arguing that the Left has to abandon the future and rediscover the past, "looking the world in the face". Contemporary capital is so infatuated with the future, and everything young and adolescent, that the Left should not

just turn to the past, but somehow make itself a thing of the past: "The Left, always embattled and marginalized, always— proudly—a thing of the past."[30] Clark thus ends up being so affirmative to the experience of defeat that he builds a new?/old? politics around it: "There will be no future without war, poverty, Malthusian panic, tyranny, cruelty, classes, dead time, and all the ills the flesh is heir to, because there will be no future."[31]

On the other hand, we have the situationists and their attempt to rebuild a new capital-negating offensive beyond art and politics in the 1960s. There is no doubt that the endgame the situationists were facing has only deteriorated further. That the stakes have only heightened. But has the game significantly changed? Is capitalist society not still characterized by a fundamental contradiction between capital and labour? A contradiction that has in fact only been further intensified with the "neo-liberal" restructuring, where more and more people are not even able to get access to capital's metabolism, but survive, outside, or on the margins, of the extraction of surplus value.

At a time where revolutionary events primarily resurface and circulate as empty signifiers, it is of course difficult to imagine the world turned upside down by a victorious proletarian revolution. Even the biggest capitalist crisis since the 1930s and the outbreak of a new global protest wave spreading from North Africa to the US and onwards have not seriously shattered capitalist-realist dogma in the West, according to which the world is more likely to disappear in biospheric meltdown than capitalism be replaced by another economic system.[32] Today, the notion of revolution has more to do with the never-failing ability of capitalism to stage yet another commodity object as *the* new thing not to be missed. "Revolution" is more likely to appear as a description of washing powder or a pair of jeans than a break with the ruling order and transformation of society.

The way revolutionary historical events suddenly surface and just as quickly slip away is indicative of the present situation.

From Alexander McQueen's autumn 2007 McQ-campaign, using photos from May to June 1968 (the spring collection of that same year featured US cheerleaders) to the sudden explosion of interest in the late 2000s in the Red Army Faction that featured in movies and exhibitions.

The point is not that revolutionary events are somehow repressed so as to be invisible, but rather that they circulate as images in an expanded memory culture that flattens out historical events, reducing them to decontextualized signifiers whose only function is "pimping your style". If the nostalgia cultures of the 1970s and 1980s were characterized by a fascination with the popular culture of the 1950s and 1960s, from adventure stories to go-go girls, and staying away from a more politicized past, as Fred Jameson argued in his seminal analysis of the postmodern, present-day nostalgia, culture has no problem mining more militant events, emblems, images and styles, converting them into fashionable signs like Che and Guy Fawkes.[33] But the end result is the same: historical amnesia and the commodification of history.

The process Jameson analysed in the mid and late 1980s seems, in fact, only to have accelerated since taking on a new dimension, where the past is now only present as memory. Pierre Nora has aptly described this as the substitution of history with memory: "Memory has taken on a meaning so broad and all-inclusive that it tends to be used purely and simply as a substitute for history," he writes.[34] The result is that we are living in an age of "passionate, almost fetishistic memoralism", where "every country, every social, ethnic or family group, has undergone a profound change in the relationship it traditionally enjoyed with the past."

This development is visible in the way the historian (and historiography in general) has lost its monopoly in interpreting the past. Access to the past has in that sense been "democratized". Today, not only the witness of history, the media, but also the

judge and the politician, have a share in the manufacturing of the past, replacing history with memory as collective meaning. One result of this change is that the decisive break that the revolutionary upheaval used to designate and constitute has now been generalized to such an extent that the sense of historical continuity has been replaced by the experience of constant change.

The present is now unable to connect the past with the future. The line binding the present and the future to the past has been shattered, Nora argues. Therefore, we are forced into stockpiling "in a pious and somewhat indiscriminate fashion, any visible trace or material sign that might eventually testify to what we are or what we will have become." The present is no longer a bridge between the past and the future, and has become autonomous; echoing Jameson's terms from his description of postmodernism, Nora writes that we are living an *"autonomising of the present"*, the future unforeseeable and the past shrouded in darkness or mist.

The future is thus locked away in an irretrievable past. The revolutions of the past are unapproachable and only resurface as one-dimensional fashion pieces put into circulation by a global nostalgia industry. A revolutionary politics of memory appears difficult today, as memory is not a neutral medium of politics, but an ideologically biased politics of post-history. "No more monuments..."

It is thus surely very difficult today to comprehend or even redo Bernstein's gesture of reversing history, or the situationists' rhetoric about a fusion of art and life in a revolutionary abolishment of capitalism. Although contemporary art is not only the object of an intense neo-liberalization, where art has, especially since 1989, become a haven for newly accumulated capital across the globe, but also still a place for ongoing dramatization of activist art and political curating—the phantasmatic world-historical dimension present in the situationists is far away.

The contradictions are obvious. On the one hand, "political" artists and curators use the art institution as a space for political discussions rarely taking place elsewhere. On the other hand, we have a booming art market—that particular market seems to have been able to dodge the crisis completely!?—in which art institutions are deeply inscribed in the global circuit of finance capital.

Of course, the point of Bernstein's "Victories of the Proletariat" was precisely that it was already pretty difficult to imagine the revolution back in 1963. That the spectacle was already trying to turn past revolutions into oblivion was a central aspect of the situationists' analysis of the spectacle. They were already confronted with an accelerated ending and still desperately tried to keep the revolutionary perspective alive. The all-or-nothing rhetoric of the SI testifies to the gale-force winds of historical oblivion. But they nonetheless still sought to combat capitalism, the spectacle, connecting disparate struggles, making visible their virtual revolutionary dimension in the present.

Where are we, then? Clark, for good reasons, wants to abandon the future-oriented stance of the Left, in order to combat the eternal present of contemporary capitalism. But this gesture risks robbing us of the means with which to combat capitalism. His attempt to get rid of mesmerizing images of the future slides into defeatism. Even worse, his intention to confront the Left is never carried through, because he is unwilling to let go of the very identity of the Left, preferring instead to drop the revolution, as if that would enable him to control the combined and uneven development (and underdevelopment) of capitalism. He ends up abandoning not just Marxism, but also the revolutionary position, in favour of a resigned Weberian analysis and anti-war/violence reformism. Clark's willingness to look the failures of the euro-modernist Left straight in the eyes is extremely welcome, but he paradoxically ends up saving the reformist, backwards-looking Left we need to get rid of in the first place in order to

develop a capital-negating political practice.

Imagining a future is risky business, but so is not imagining anything at all. We cannot wipe our hands of the future once and for all. And a politics of "the lesser evil" is definitely not a guarantee of lesser violence, but more often than not ends up as a precondition for more violence. The established workers' movement and its programmatic project have gone and we somehow have to start from scratch with the knowledge that we might actually already have won: "Victories of the Proletariat". The ruins of the future lay before us. Capitalism is dead; its subjectless logic has already been abolished. That this is what victory looks like. We have already won. "Forward! Not forgetting!"[35]

Notes

Introduction

1. Jameson, Fredric: *The Political Unconscious: Narrative as a Socially Symbolic Act* (Ithaca: Cornell University Press, 1981) p. 102.

2. Trotsky, Leon: *The History of the Russian Revolution*, trans. Eastman, Max; https://www.marxists.org/archive/trotsky/1930/hrr/

3. Marx, Karl: *Grundrisse: Foundations of the Critique of Political Economy*, trans. Nicolaus, Martin; https://www.marxists.org/archive/marx/works/1857/grundrisse/ch09.htm

4. Foster, Hal: *Bad New Days: Art, Criticism, Emergency* (London & New York: Verso, 2015) p. 1.

5. Bourdieu, Pierre: *The Rules of Art: Genesis and Structure of the Literary Field*, trans. Emanuel, Susan (Stanford: Stanford University Press, 1995).

6. Foster, Hal: *Design and Crime (And Other Diatribes)* (London & New York: Verso, 2002) p. 42.

7. The global art market (auction houses and high-end galleries) was one of the few markets that seemed to be able to avoid a crash after 2007–2008, but from 2016 onwards it seems as if things might be changing. Cf. Russell, Anna & Crow, Kelly: "Art Auctions Show Market in a Correction", in *Wall Street Journal*, 16 February 2016; http://www.wsj.com/articles/london-art-auctions-show-market-in-a-correction-1455232298

8. Adorno, Theodor W.: "Cultural Industry Reconsidered", trans. Rabinbach, Anson, in: *New German Critique*, no. 6, 1975, pp. 12–19; Debord, Guy: *Society of the Spectacle*, trans. Nicholson-Smith, Donald (New York: Zone Books, 1995).

9. Holmes, Brian: "Liar's Poker: The Representation of Politics/The Politics of Representation", in: *Springerin*, no. 3, 2003;

www.springerin.at/dyn/heft_text.php?textid=1276&lang=en

10. Rancière, Jacques: *Disagreement: Politics and*, trans. Rose, Julie (Minneapolis & London: University of Minnesota Press, 1999) p. 121.

11. Marcuse, Herbert: "The Affirmative Character of Culture", trans. Shapiro, Jeremy J., in: *idem: Negations: Essays in Critical Theory* (London: Mayfly Books, 2009) p. 87.

12. Cf. Schulte-Sasse, Jochen: "Imagination and Modernity: or the Taming of the Human Mind", in: *Cultural Critique*, no. 5, 1987, pp. 23–48.

13. Adorno, Theodor W.: *Aesthetic Theory*, trans. Hullot-Kentor, Robert (London & New York: Continuum, 2002) p. 251.

Chapter 1: The Double Nature of Contemporary Art

1. Western Marxism was the critical Marxism that arose in Western Europe after 1917, in opposition to and as criticism of dogmatic Soviet communism and the state-capitalist party dictatorship that quickly became a reality in the Soviet Union. The Western Marxists tried to formulate alternatives to the quickly consolidated Soviet communism. They also took a sceptical view of Lenin's idea of the Party and questioned the applicability of the Russian Revolution as a model for other European nations. Leading figures in this work included Georg Lukács and Karl Korsch. After World War II, the critical mapping of the burgeoning consumer society became one of the focuses for the next generation of this tradition, which included Theodor W. Adorno, Henri Lefebvre, Cornelius Castoriadis and Guy Debord. The idea of art as an instrument of resistance played an important role for a number of Western Marxists; for example, several representatives of the Frankfurt School, the French "everyday philosophers" and the SI. For presentations of this tradition, see Anderson, Perry: *Considerations on Western Marxism* (London: NLB, 1971), Gombin, Richard: *Les origines du gauchisme* (Paris: Seuil, 1971) and Jacoby, Russell: *Dialectics of Defeat: Contours of Western Marxism* (Cambridge &

New York: Cambridge University Press, 1981).

2. In *Hegemonie im Kunstfeld. Die documenta-Ausstellungen dX, D11, d12 und die Politik der Biennalisierung* (Cologne: Neuer Berliner Kunstverein & Walter König, 2008) Oliver Marchart uses a Laclau-Mouffe-inspired discursive analysis to analyse DX and Documenta XI as an attempt to give the public sphere of art a political function.

3. Holmes, Brian: "Liar's Poker. Representation of Politics/ Politics of Representation", in: *Springerin*, no. 1, 2003; www. springerin.at/dyn/heft_text.php?textid=1276&lang=en

4. Cf. Rectanus, Mark: *Culture Incorporated: Museums, Artists and Corporate Sponsorship* (Minneapolis & London: University of Minnesota Press, 2002), Tao-Wu, Chin: *Privatising Culture: Corporate Art Intervention since the 1980s* (London & New York: Verso, 2001) and Davies, Anthony: "Take Me I'm Yours: Neoliberalising the Cultural Institution", in: *Mute*, vol. 2, no. 5, 2007, pp. 100–113.

5. For analyses of this use of art and art institutions, see Vicario, Lorenzo & Martinez Monje, Pedro Manuel: "The Guggenheim Effect", in: *Shrinking Cities. Volume 2: Interventions* (Ostfildern: Hatje Cantz, 2006) pp. 744–752 and Zukin, Sharon: "How to Create a Culture Capital: Reflections on Urban Markets and Places", in: Blazwick, Iwona (ed.): *Century City: Art and Culture in the Modern Metropolis* (London: Tate Gallery Publishing, 2001) pp. 258–264. The reprogramming of the artist as the avant-garde of gentrification was formulated in exemplary fashion by Florida, Richard: *The Rise of the Creative Class: And How It's Transforming Work, Leisure and Everyday Life* (New York: Basic Books, 2002).

6. Stallabrass, Julian: *Art Incorporated: The Story of Contemporary Art* (Oxford: Oxford University Press, 2004) pp. 29–43.

7. Situationist International: "The Role of Godard", trans. Not Bored; http://www.bopsecrets.org/SI/10.godard.htm

8. Foster, Hal: "Against Pluralism", in: *Recodings: Art, Spectacle, Cultural Politics* (Seattle: Bay Press, 1985) pp. 13–32.

9. Bourriaud, Nicolas: *Relational Aesthetics*, trans. Pleasance, Simon & Woods, Fronza (Dijon: Les presses du reel, 2002).

10. Cf. Foster, Hal: "Arty Party", in: *London Review of Books*, December 2003, pp. 21–22 and Martin, Stewart: "Critique of Relational Aesthetics", in: *Third Text*, 2007, no. 87, pp. 369–386.

11. Superflex & Steiner, Barbara (eds.): *Tools* (Cologne: Walter König, 2003) and Esche, Charles: *Modest Proposals* (Istanbul: Baglam Publishing, 2005).

12. Rancière, Jacques: *Chronicles of Consensual Times*, trans. Corcoran, Steven (London & New York: Continuum, 2010) pp. vii–viii.

13. For a presentation of the project, see Bradley, Will: "Guaraná Power", Superflex et al. (eds.): *Self-organisation/counter-economic strategies* (New York & Berlin: Sternberg Press, 2006) pp. 311–333.

14. Some of the "classic" texts on the tactic include the autonomous a.f.r.i.k.a group, Blissett, Luther & Brünzels, Sonja (eds.): *Handbuch der Kommunikationsguerilla* (Hamburg: Verlag Libertäre Assoziation & Schwarze Risse/Rote Strasse, 1997), Critical Art Ensemble: *Digital Resistance: Explorations in Tactical Media* (New York: Autonomedia, 2001) and Lovink, Geert & Garcia, David: "ABC of Tactical Media"; www.nettime.org/Lists-Archives/ nettime-l-9705/msg00096.html

15. Cf. the theme issue of *Third Text* (no. 94, 2008) with the title "Whither Tactical Media?", edited by Ray, Gene & Sholette, Gregory, who take their point of departure in the gradual absorption of the tactics by the art institution.

16. Klein, Naomi: *No Logo: Taking Aim at the Brand Bullies* (New York: Picador, 2000).

17. Faldbakken, Matias: *The Cocka Hola Company* (Oslo: Cappelen Damm, 2001) and *Macht und Rebel. Skandinavisk misantropi* (Oslo: Cappelen Damm, 2002).

18. Cf. Losurdo, Domenico: *Il revisionismo storico. Problemi e miti* (Bari: Laterza, 1996), Žižek, Slavoj: *Did Somebody Say Totalitarianism? Five Interventions in the (Mis)Use of a Notion* (London & New York: Verso, 2001).

19. Cf. Benjamin, Walter: *The Arcades Project*, trans. Eiland, Howard & McLaughlin, Kevin (Cambridge, MA & London: Harvard University Press, 2002) pp. 4–5.

Chapter 2: The Self-Murder of the Avant-Garde

1. Artaud, Antonin: "In Total Darkness, or The Surrealist Bluff", trans. Sontag, Susan, in: *Selected Writings* (Berkeley & Los Angeles: University of California Press, 1988) p. 139.
2. Bürger, Peter: *Theory of the Avant-Garde*, trans. Shaw, Michael (Minneapolis: University of Minnesota Press, 1984) p. 58.
3. For a critique of Bürger's notion of history, see Foster, Hal: *The Return of the Real* (Cambridge: The MIT Press, 1996). For a critique of Bürger's lack of a broader historical context within which the transformation of the avant-garde project takes place, see Berman, Russell: *Modern Culture and Critical Theory* (Madison: The University of Wisconsin Press, 1989). The most interesting responses to Bürger's thesis remains the essays collected in Lüdke, Martin (ed.): *"Theorie der Avantgarde". Antworten auf Peter Bürgers Bestimmung von Kunst und bürgerlicher Gesellschaft* (Frankfurt: Suhrkamp, 1976). Recent discussions of the avant-garde include Léger, Marc James: *Brave New Avant Garde: Essays on Contemporary Art and Politics* (Winchester & Washington: Zero, 2012) and Roberts, John: *Revolutionary Time and the Avant-Garde* (London & New York: Verso, 2015).
4. Camatte, Jacques: *Capital and Community*, trans. Brown, David; http://www.marxists.org/archive/camatte/capcom/index.htm
5. Adorno, Theodor W. & Horkheimer, Max: "The Culture Industry: Enlightenment as Mass Deception", in: *Dialectics of Enlightenment: Philosophical Fragments*, trans. Jephcott, Edmund (Stanford: Stanford University Press, [1944] 2002) pp. 94–136.
6. It was especially Left communists like Cornelius Castoriadis

and Jean-François Lyotard who initiated the necessary reworking of historical materialism's suspect notion of history. For important contributions to this development, see Castoriadis, Cornelius: "Modern Capitalism and Revolution", trans. Brinton, Maurice; http://libcom.org/library/modern-capitalism-revolution-paul-cardan, and Lyotard, Jean-François: *Libidinal Economy*, trans. Grant, Iain Hamilton (Bloomington: Indiana University Press, [1974] 1993).

7. Cf. Marelli, Gianfranco: *L'ultima Internazionnale. I situazionista oltre l'arte et la politica* (Torino: Bollati Boringhieri, 2000) and Bolt Rasmussen, Mikkel: *Den sidste avantgarde. Situationistisk Internationale hinsides kunst og politik* (Copenhagen: Politisk revy, 2004).

8. Anderson, Perry: *The Origins of Postmodernity* (London: Verso, 1998) p. 82.

9. For a comparison of these different projects, see Bolt Rasmussen, Mikkel: "The Politics of Interventionist Art: The Situationist International, Artist Placement Group, and Art Workers' Coalition", in: *Rethinking Marxism*, vol . 21, no. 1, 2009, pp. 34–49.

10. Guy Debord in a letter dated 15 March 1963 to Robert Estivals, trans. Not Bored; http://www.notbored.org/debord-15March1963.html.

11. Guy Debord letter, 15 March 1963.

12. Tiqqun: "The problem of the Head", trans. anonymous; http://headproblems.jottit.com/part_1.

13. Mann, Paul: *The Theory-Death of the Avant-Garde* (Bloomington & Indianapolis: Indiana University Press, 1991).

14. "Just as God constituted the reference point of past unitary society, we are preparing to create the central reference point for a new unitary society now possible." Cited in Vaneigem, Raoul: "Basic Banalities", trans. Knabb, Ken; http://www.bopsecrets.org/SI/8.basic2.htm

15. Camatte, Jacques & Collu, Gianni: "On Organization",

trans. Edizioni International, in: *This World We Must Leave and Other Essays* (New York: Autonomedia, 1995) pp. 28–29.

16. Ibid., p. 29.

17. Tiqqun: "The problem of the Head".

18. When the twelfth and last issue of the group's journal, *Internationale situationniste*, was published in 1969, it contained a long analysis of the events of May–June 1968 with that title, "The Beginning of an Epoch".

19. Debord, Guy: "Report on the Construction of Situations and on the Terms of Organization and Action of the International Situationist Tendency", trans. McDonough, Tom, in: McDonough, Tom (ed.): *Guy Debord and the Situationist International* (Cambridge: The MIT Press, 2002) p. 29.

20. Debord, Guy: "Report on the Construction of Situations", p. 29.

21. Camatte, Jacques: "The Wandering of Humanity", trans. Perlman, Freddy, in: *This World We Must Leave and Other Essays*, p. 45.

22. Tafuri, Manfredo: *Architecture and Utopia: Design and Capitalist Development*, trans. Luigia La Penta, Barbara (Cambridge, MA: The MIT Press, 1976).

23. Ibid., p. 50.

24. "The revolutionary knows that in the very depths of his being, not only in words but also in deeds, he has broken all the bonds which tie him to the social order and the civilized world with all its laws, moralities, and customs, and with all its generally accepted conventions. He is their implacable enemy, and if he continues to live with them it is only in order to destroy them more speedily." Nechayev, Sergej & Bakunin, Mikhail: "The Revolutionary Catechism", trans. unknown; http://www.marxists.org/subject/anarchism/nechayev/catechism.htm. For a good description of Russian anarchism, see Franco Venturi's classic account in *Roots of Revolution: A History of the Populist and Socialist Movement in*

19th Century Russia, trans. Haskell, Francis (London: Phoenix Press, 2001).

25. For analyses of the relationship between the surrealist group and the French Communist Party, see Nadeau, Maurice: *The History of Surrealism*, trans. Howard, Richard (Cambridge: Harvard University Press, 1989); Short, Robert S.: "The Politics of Surrealism, 1920–36", in: *The Journal of Contemporary History*, no. 2, 1966, pp. 3–25; and Thirion, André: *Révolutionnaires sans révolution* (Paris: Éditions Robert Laffont, 1972).

26. Breton was on several occasions taken to task by the Communist Party's central committee for surrealist actions and publications. See *Entretiens* (Paris: Gallimard, 1969).

27. For a description of the French Communist Party, see Caute, David: *Communism and the French Intellectuals 1914–1960* (London: Andre Deutsch, 1964). For a description of the Communist Party's view of surrealism, see also chapter five in Fauvet, Jacques & Duhamel, Alain: *Histoire du Parti Communiste Français de 1920 à 1976* (Paris: Fayard, 1977).

28. See Lih, Lars T.: *Lenin* (London: Reaktion Books, 2011).

29. The documents from the congress are collected in Klein, Wolfgang & Teroni, Sandra (eds.): *Pour le défense de la culture. Les textes du Congrès international des écrivains. Paris, Juin 1935* (Dijon: Éditions universitaires de Dijon, 2005).

30. Breton, André: "Speech to the Congress of Writers", in: *Manifestoes of Surrealism*, trans. Seaver, Richard & Lane, Helen (Ann Arbor: University of Michigan Press, 1972) p. 241.

31. Groys, Boris: *The Total Art of Stalinism: Avant-Garde, Aesthetic Dictatorship, and Beyond*, trans. Rougle, Charles (Princeton: Princeton University Press, 1992).

32. See Rancière, Jacques: "Mode d'emploi pour une réédition de *Lire le 'Capital'*", in: *Les Temps modernes*, no. 328, 1973, pp. 788–807.

33. Rancière, Jacques: *The Philosopher and His Poor*, trans. Drury, John, Oster, Corinne & Parker, Andrew (Durham: Duke University Press, 2004) p. 132.
34. Rancière quoting from *The Communist Manifesto*, in Rancière, Jacques: *The Philosopher and His Poor*, p. 76.
35. Rancière, Jacques: *The Philosopher and His Poor*, pp. 85–86.
36. Nancy, Jean-Luc: "'What is to be done?'", trans. Hill, Leslie, in: Lacoue-Labarthe, Philippe & Nancy, Jean-Luc: *Retreating the Political* (London: Routledge, 1997) p. 157.

Chapter 3: After Credit, Winter

1. Arrighi, Giovanni: *The Long Twentieth Century: Money, Power and the Origins of Our Times* (London & New York: Verso, 1994). A new edition with a new afterword came out in 2009.
2. The notion that financial expansion announces the autumn of a particular hegemonic system and cycle of accumulation was originally developed by Braudel in *The Perspective of the World: Civilization and Capitalism Fifteenth to Eighteenth Century*, trans. Reynold, Sian (Berkeley & London: University of California Press, 1992). Arrighi picks up the notion and puts it to use in *The Long Twentieth Century*.
3. Cf. Colatrella, Steven: "In Our Hands is Placed a Power: A Worldwide Strike Wave, Austerity and the Political Crisis of Global Governance", in: *Wildcat*, no. 90, 2011; http://www.wildcat-www.de/en/wildcat/90/e_w90_in_our_hands.html
4. There's no doubt that the institutional scene in Western Europe and the US are almost incomparable when it comes to the question of political art. In the US, political art never acquired the "popularity" it did in Europe (as the resignation of Gilbert also shows). This was also owing to the much bigger impact "the war on terror" had in the US, effecting both base and superstructure in a much more visible way. The Steve Kurtz case, where Kurtz from Critical Art Ensemble was charged with bioterrorism and the case

was dismissed in 2008, and where half the artists in "The Interventionists" were subpoenaed, was one example of this tightening of the public sphere. Cf. Sholette, Gregory: "Disciplining the Avant-Garde: The United States versus the Critical Art Ensemble", in: *Circa*, no. 112, pp. 50–59.

5. Stallabrass, Julian: *Art Incorporated: The Story of Contemporary Art* (Oxford & New York: Oxford University Press, 2004) p. 72.

6. Anderson, Perry: "Renewals", in: *New Left Review: New Series*, no. 1, 2000, p. 14.

7. Holmes, Brian: "Liar's Poker: Representation of Politics/ Politics of Representation", in: *Springerin*, no. 1, 2003; http://www.springerin.at/dyn/heft_text.php?textid=1276&lang=en

8. Esche, Charles: *Modest Proposals* (Istanbul: Baglam, 2005).

9. Boltanski, Luc & Chiapello, Ève: *The New Spirit of Capitalism*, trans. Elliot, Gregory (London & New York: Verso, 2005).

10. Cf. Lundell, Kerstin: *Affärer i blod och olja. Lundin Petroleum i Afrika* (Stockholm: Ordfront, 2010). See also the 2010 report *Unpaid Debt: the Legacy of Lundin, Petronas and OMV in Block 5A, Sudan 1997–2003* by ECOS (European Coalition on Oil in Sudan). "The actual perpetrators of the reported crimes were the armed forces of the Government of Sudan and a variety of local armed groups that were either allied to the Government or its main opponent, the Sudan People's Liberation Movement/Army (SPLM/A). Nonetheless, the evidence presented in this report calls into question the role played by the oil industry in these events. [...] The start of oil exploitation set off a vicious war in the area. Between 1997 and 2003, international crimes were committed on a large scale in what was essentially a military campaign by the Government of Sudan to secure and take control of the oil fields in Block 5A. As documented in this report, they included indiscriminate attacks and intentional targeting of civilians, burning of shelters, pillage, destruction of

objects necessary to survival, unlawful killing of civilians, rape of women, abduction of children, torture, and forced displacement. Thousands of people died and almost two hundred thousand were violently displaced." p. 5.

11. For an analysis of the global political economy of oil and the weapondollar-petrodollar coalition, see Nitzan, Jonathan & Bichler, Shimshon: *The Global Political Ecomomy of Israel* (London: Pluto, 1999).

12. Davies, Anthony: "Take Me I'm Yours: Neoliberalising the Cultural Institution", in: *Mute*, vol. 2, no. 5, 2007, p. 107.

Chapter 4: The Long March Through the Institutions

1. "Revolution 67", a panel discussion in Hamburg on 24 November 1967. See Dutschke-Klotz, Gretschen, Gollwitzer, Hellmut & Miermeister, Jürgen (eds.): *Rudi Dutschke. Mein Langer Marsch* (Berlin: Rowolt, 1993) p. 15.

2. For a good account of the development of Dutschke's thinking, see Karl, Michaela: *Rudi Dutschke. Revolutionär ohne Revolution* (Frankfurt: Neue Kritik, 2003).

3. "Zu Protokoll: Rudi Dutschke", TV interview with Günter Gaus, Südwestfunk Baden-Baden, 3 December 1967. See Dutschke-Klotz, Gretschen et al. (eds.): *Rudi Dutschke. Mein Langer Marsch*, pp. 42–57.

4. See Dutschke, Rudi: *Jeder hat sein Leben ganz zu leben. Die Tagebücher 1963–1979* (Cologne: Kiepenheuer und Witsch, 2003).

5. Boltanski, Luc & Chiapello, Ève: *The New Spirit of Capitalism*, trans. Elliot, Gregory (London & New York: Verso, 2005).

6. These demonstrations have lived on within political philosophy thanks to Jacques Rancière, who uses the students' actions as his favourite example of political subjectivization, in which a group denounces their identity and social role in favour of an "impossible" transgressive identity, thereby demanding a reshuffling of the sharing

of the sensible. In 2008, André & Raphael Glucksmann's *père et fils* provided a bizarre retrospective account of the slogan that turns out to have been a call for EU solidarity and support for the EU. Glucksmann, André & Raphael: *Mai 68 expliqué à Nicolas Sarkozy* (Paris: Denoël, 2008) pp. 37–88.

7. Bürger, Peter: *Theory of the Avant-Garde*, trans. Shaw, Michael (Minneapolis: University of Minnesota Press, 1984), p. 58.

8. Bürger, Peter: *Der französische Surrealismus. Studien zur avantgardistischen Literatur* (Frankfurt: Suhrkamp, 1996).

9. Fraser, Andrea: "From the Critique of Institutions to an Institution of Critique", in: *Artforum*, vol. 44, no. 1 (2005) p. 282.

10. Fisher, Mark: *Ghosts of my Life* (London: Zero Books, 2014) p. 223.

11. Fisher, Mark & Möntmann, Nina: "Peripheral Proposals", in: Binna Choi et al. (eds.): *Cluster: Dialectionary* (Berlin: Sternberg Press, 2014) p. 176.

12. Mouffe, Chantal: "Strategies of Radical Politics and Aesthetic Resistance", in: Malzacher, Florian (ed.): *Truth is Concrete: A Handbook for Artistic Strategies in Real Politics* (Berlin: Sternberg Press, 2014) p. 72.

13. Ibid., p. 73.

14. Kurz, Robert: "Subjektlose Herrschaft. Zur Aufhebung einer verkürzten Gesellschaftkritik", in: *Blutige Vernunft. Essays zur emanzipatorischen Kritik der kapitalistischen Moderne und ihrer westlichen Werte* (Bad Honnef: Horlemann, 2004) pp. 153–221.

15. Marx, Karl: *Capital: A Critique of Political Economy. Vol. I*, trans. Fowkes, Ben (London: Penguin, 1990) p. 253.

16. For a critique of *The Killburn Manifesto*, see Bolt Rasmussen, Mikkel: *Crisis to Insurrection: Notes on the Ongoing Collapse*, (New York & Wivenhoe: Minor Compositions, 2015) pp. 139–143.

17. Negri, Toni: "No New Deal is Possible", trans. Bove,

Arianna, in: *Radical Philosophy*, no. 155, 2009, pp. 2–5.

18. Poulantzas, Nicos: *State, Power, Socialism*, trans. Camiller, Patrick (London: Verso, 2000).

19. "Revolution 67", Dutschke in a panel discussion in Hamburg, 24 November 1967, in: Dutschke-Klotz, Gretschen et al. (eds.): *Rudi Dutschke. Mein Langer Marsch*, p. 16.

Chapter 5: Globalization, Architecture and Containers

1. The Invisible Committee: *To Our Friends*, trans. Hurley, Robert (Los Angeles: Semiotext(e), 2015) p. 87.

2. INSEAD, press release 2013; http://www.insead.edu/media_relations/press_release/2013_industrial-excellence-awards.cfm

3. Tafuri, Manfredo & Co, Francesco del: *Modern Architecture* (New York: H. N. Abrams, 1979) pp. 163–164.

4. See https://www.youtube.com/watch?v=jL13eOXmVjY

5. Foster, Hal: *The Art-Architecture Complex* (London & New York: Verso, 2011) p. 85.

6. Jameson, Fredric: *Postmodernism, or, The Cultural Logic of Late Capitalism* (London & New York: Verso, 1991).

7. Zaha Hadid in conversation with Hans Ulrich Obrist, *Zaha Hadid and Hans Ulrich Obrist: The Conversation Series* (Cologne: Walter König, 2007) p. 64.

8. Ibid., p. 65.

9. Deleuze, Gilles: "Postscript on Control Societies", trans. Joughin, Martin, in *Negotiations* (New York: Columbia University Press, 1995) pp. 169–176.

10. Papadopoulos, Dimitris, Stephenson, Nuamh & Tsianos, Vassilis: *Escape Routes: Control and Subversion in the 21st Century* (London: Pluto Press, 2008) p. 26.

11. Ibid., p. 26.

12. Levinson, Marc: *The Box: How the Shipping Container made the World Smaller and the World Economy Bigger* (Princeton & Oxford: Princeton University Press, 2008).

137

13. Reifer, Thomas: "Unlocking the Black Box of Globalization", 2011, unpublished paper, quoted in Cowen, Deborah: *The Deadly Life of Logistics: Mapping Violence in Global Trade* (Minneapolis & London: University of Minnesota Press, 2014) p. 104.

14. Womack, James P., Jones, Daniel T. & Ross, Daniel: *The Machine that Changed the System: The Story of Lean Production* (New York: Rawson Associates, 1990).

15. Klose, Alexander: *The Container Principle: How a Box Changes the Way We Think*, trans. Marcrum, Charles (Cambridge, MA & London: MIT Press, 2015) p. 5.

16. Ibid., p. 8.

17. As Beverly Silver argues, the outsourcing of industrial production to the former periphery of capitalist accumulation and deindustrialization of the centre is, of course, only a postponement of class struggle, as workers in South East Asia and China are beginning to protest and strike for better wages and better working conditions. Silver, Beverly: *Forces of Labour: Workers' Movement and Globalization since 1870* (Cambridge & New York: Cambridge University Press, 2003). For an overview of the huge increase in the number of strikes in China, see Mouvement Communiste & Kolektivne Proti Kapitalu: *Workers' Autonomy Strikes in China*, 2011; http://mouvement-communiste.com/documents/MC/Booklets/BR1_China_EN_vF_Complete.pdf

18. Simon, David: "Port in a Storm", dir. Colesberry, Robert F., *The Wire*, season 2, episode 12.

19. Napoleon quoted by military historian and former F-15 pilot Jeff Patton in "Logistics and the Western Way of War", in: *Military History Online*, 2013; http://www.militaryhistoryonline.com/general/articles/logistics westernway.aspx

20. Harney, Stefano & Moten, Fred: *The Undercommons: Fugitive Planning & Black Study* (Wivenhoe & New York: Minor

Compositions, 2013) p. 88.

21. Cowen, Deborah: *The Deadly Life of Logistics: Mapping Violence in Global Trade* (Minneapolis & London: University of Minnesota Press, 2014).

22. The standard work on the decline of the major economies since the 1970s remains Robert Brenner's. See for instance *The Economics of Global Turbulence: The Advanced Capitalist Economies from Long Boom to Long Downturn, 1945–2005* (London & New York: Verso, 2006). For an analysis based on a class-war perspective, see Goldner, Loren: "The Historical Moment That Produced Us: Global Revolution or Recomposition of Capital", in: *Insurgent Notes: Journal of Communist Theory and Practice*, no. 1, 2010; http://insurgentnotes.com/2010/06/historical_moment/

23. Cowen, Deborah: *The Deadly Life of Logistics*, p. 3.

24. Neilson, Brett & Rossiter, Ned: "Still Waiting, Still Moving: On Labour, Logistics and Maritime Industries", in: Bissell, Davis & Fuller, Gillian (eds.): *Stillness in a Mobile World* (London: Routledge, 2011) p. 53.

25. Hardt, Michael & Negri, Antonio: *Multitude: War and Democracy in the Age of Empire* (New York: The New Press, 2004) p. 3.

26. Cowen, Deborah: *The Deadly Life of Logistics*, p. 11.

27. The Invisible Committee: *To Our Friends*, p. 84.

28. Harney, Stefano & Moten, Fred: *The Undercommons*, p. 90.

29. Denning, Michael: "Wageless Life", in: *New Left Review*, no. 66, 2010, pp. 79–97.

30. Endnotes: "Misery and Debt", in: *Endnotes*, no. 2, 2010, p. 51.

31. Cf. Plöger, Jörg: "Learning from Abroad: Lessons from European Shrinking Cities", in: Mallach, Alan (ed.): *Rebuilding America's Legacy Cities: New Directions for the Industrial Heartland* (New York: The American Assembly, 2012) pp. 295–321.

32. Jameson, Fredric: *Valences of the Dialectic* (London & New

York: Verso, 2009) p. 423.

33. Ibid., p. 422.

34. See the exchanges between Alberto Toscano and Jasper Bernes, in which Bernes takes Toscano to task for being too "positive": Toscano, Alberto: "Logistics and Opposition", in: *Mute*, 2011; http://www.metamute.org/editorial/articl es/logistics-and-opposition; Bernes, Jasper: "Logistics, Counterlogistics and the Communist Prospect", in: *Endnotes*, no. 3, 2013, pp. 172–201; Toscano, Alberto: "Lineaments of the Logistical State", in: *Viewpoint Magazine*, no. 4, 2014; https://viewpointmag.com/2014/09/28/lineaments-of-the-logistical-state/

Chapter 6: Imagining a Future

1. Adorno, Theodor W. & Horkheimer, Max: *Towards a New Manifesto*, trans. Livingstone, Rodney (London & New York: Verso, 2011) p. 70.

2. Clark, T.J.: "For a Left With No Future", in: *New Left Review*, no. 74, 2012, pp. 53–75.

3. Ibid., p. 54.

4. Buck-Morss, Susan: *Dreamworld and Catastrophe: The Passing of Mass Utopia in East and West* (Cambridge, MA & London: MIT Press, 2002).

5. Ibid., p. 57. Clark thus continues a critique of the avant-garde that was also present in *Afflicted Powers: Capital and Spectacle in a New Age of War* (London & New York: Verso, 2005), co-written with Iain Boal, Joseph Matthews and Michael Watts under the name of Retort, where al-Qaida was analysed as the last vanguard. "The Left should approach al-Qaida in the same spirit [as Nietzsche did]—with the words and actions of bin Laden resonating against those of Lenin, Blanqui, Mao, Baader-Meinhof, and Durruti." p. 173. Notice the lumping together of quite different historical figures from Mao to Durruti, whose "politics" cannot easily be described

as the same. But, of course, that's Clark's argument, that the tenor is the same from Blanqui via Lenin to bin Laden, that they all share the same futuristic rhetoric and ultimately all of them exhibit the same merciless instrumentalism.

6. Ibid., p. 54.

7. "The bourgeoisie, historically, has played a most revolutionary part. [...] It has pitilessly torn asunder the motley feudal ties that bound man to his 'natural superiors', and has left remaining no other nexus between man and man than naked self-interest, than callous 'cash payment'. [...] The bourgeoisie has stripped of its halo every occupation hitherto honoured and looked up to with reverent awe. It has converted the physician, the lawyer, the priest, the poet, the man of science, into its paid wage labourers. [...] The bourgeoisie cannot exist without constantly revolutionising the instruments of production, and thereby the relations of production, and with them the whole relations of society. [...] Constant revolutionising of production, uninterrupted disturbance of all social conditions, everlasting uncertainty and agitation distinguish the bourgeois epoch from all earlier ones. All fixed, fast-frozen relations, with their train of ancient and venerable prejudices and opinions, are swept away, all new-formed ones become antiquated before they can ossify. [...] [But today] [t]he weapons with which the bourgeoisie felled feudalism to the ground are now turned against the bourgeoisie itself." Marx, Karl & Engels, Friedrich: *Manifesto of the Communist Party*, trans. Moore, Samuel; https://www.marxists.org/archive/marx/works/1848/communist-manifesto/index.htm

8. Clark, T.J.: "For a Left With No Future", p. 62.

9. Ibid., p. 63. Clark refers to Nietzsche's famous note on European nihilism from 10 June 1887, published by his sister posthumously in *The Will to Power*, where Nietzsche writes: "Who will prove to be the strongest in the course of this?

The most moderate; those who do not require any extreme articles of faith; those who not only concede but love a fair amount of accidents and nonsense; those who can think of man with a considerable reduction of his value without becoming small and weak on that account; those richest in health who are equal to most misfortunes and therefore not so afraid of misfortunes—human beings who are sure of their power and represent the attained strength of humanity with conscious pride." *The Will to Power*, trans. Kaufmann, Walter & Hollingdale, R.J. (New York: Vintage, 1968) pp. 38–39.

10. Ibid., p. 66. "Aggression and human violence have marked the progress of our civilization and appear, indeed, to have grown so during its course that they have become a central problem of the present. Analyses that attempt to locate the roots of the evil often set out with short-sighted assumptions, as though the failure of our upbringing or the fatal development of a particular national tradition or economic system were to blame. More can be said for the thesis that all orders and forms of authority in human society are founded on institutionalized violence." Burkert, Walter: *Homo Necans: The Anthropology of Ancient Greek Sacrificial Ritual and Myth*, trans. Bing, Peter (Berkeley & Los Angeles & London: University of California Press, 1983) p.1.

11. Ibid., p. 67.

12. The formulation is Pierre Nora's, who describes this memoralism as "a kind of tidal wave of memorial concerns that has broken over the world, everywhere establishing close ties between respect for the past—whether real or imaginary—and the sense of belonging, collective consciousness and individual self-awareness, memory and identity." Nora, Pierre: "Reasons for the Current Upsurge in Memory", in: *Eurozine*, 19 April 2002; http://www.eurozine.com/articles/2002-04-19-nora-en.html

13. Clark, T.J.: "Origins of the Present Crisis", in: *New Left Review*, no. 2, 2000, p. 85–96.

14. Ibid., p. 57.

15. Cf. Toscano, Alberto: "Politics in a Tragic Key", in: *Radical Philosophy*, no. 180, 2013, pp. 25–34.

16. Clark was, of course, a member of the SI in 1966–1967. He has rarely directly engaged in a reading of the situationist project or directly used the terms and concepts of the situationists; although Debord does pop up at strategic points in his art historical works, most notably in *The Painting of Modern Life: Paris in the Art of Manet and his Followers* (London: Thames & Hudson, 1985). *Afflicted Powers* is the primary exemption— here, Clark engages in a putting into analysis of the concepts of spectacle and the critique of everyday life. With Donald Nicholson-Smith, Clark has written one longer text about the situationists attacking Peter Wollen and others for being overly focused on art, and not getting the situationist project: "Why Art Can't Kill the Situationist International?", in: *October*, no. 79, 1997, pp. 15–31.

17. Susan Watkins makes a similar critique in her rebuttal to Clark in "Presentism? A Reply to T.J. Clark", published in the same issue of *New Left Review* as Clark's article. *New Left Review*, no. 74, 2012, pp. 77–102. Clark's use of a Weberian language really took off in *Farewell to An Idea: Episodes from a History of Modernism* (New Haven & London: Yale University Press, 1999), where Weber's "disenchantment of the world" is described as the best summing up of modernity, p. 7.

18. Ibid., pp. 60–61.

19. Power, Nina: "The Pessimism of Time", in: *Overland*, no. 209, 2012; https://overland.org.au/previous-issues/issue-209/feature-nina-power/

20. Ibid., p. 55.

21. Cf. Simon, Roland: *Fondements critiques d'une théorie de la révolution. Au-delà de l'affirmation du prolétariat* (Marseilles:

Senonevero, 2001). The so-called communization theory developed by different post-ultra Left groups after the defeat of May 1968 in France, notably Théorie Communiste, talks about the "programmatic" phase of the working-class movement, in which the class struggle of the proletariat took the form of a liberation of the working class from capitalism. The goal was to increase the strength of the working class within the capitalist mode of production through the taking of power. This phase is now over, Théorie Communiste argues.

22. Clark, TJ.: "For a Left With No Future", p. 55.
23. "There is no such thing as *Situationism* or a Situationist work of art or a spectacular Situationist". "The Fifth SI Conference in Göteborg", trans. Knabb, Ken, in: *Situationist International Anthology* (Berkeley: Bureau of Public Secrets, 1981) p. 88.
24. For a more in-depth analysis of "Destruction of RSG-6", including the reception in the Danish press, see Bolt Rasmussen, Mikkel: "To Act in Culture While Being Against All Culture: The Situationists and the 'Destruction of RSG-6'", in: Bolt Rasmussen, Mikkel & Jakobsen, Jakob (eds.): *Expect Anything Fear Nothing: The Situationist Movement in Scandinavia and Elsewhere* (Copenhagen: Nebula, 2011) pp. 75–113.
25. The activists called themselves Spies for Peace and were associated with the Committee of 100. On the action, see: "The Spies for Peace and After", in: *The Raven: Anarchist Quarterly*, no. 5, 1988, pp. 61–96; Caroll, Sam: "Danger! Official Secret!", in: *History Workshop Journal*, no. 69, 2010, pp. 158–176.
26. "Geopolitics of Hibernation", trans. Knabb, Ken, in: *Situationist International Anthology* (Berkeley: Bureau of Public Secrets, 1981) pp. 76–82.
27. Debord, Guy: "The Situationists and the New Forms of Action in Politics and Art", trans. McDonough, Tom, in:

McDonough, Tom (ed.). *Guy Debord and the Situationist International: Texts and Documents* (Cambridge, MA & London: MIT Press, 2002) p. 159.

28. Ibid., p. 165.
29. Agamben, Giorgio: "Difference and Repetition in Guy Debord's Films", trans. Holmes, Brian, in: McDonough, Tom (ed.). *Guy Debord and the Situationist International: Texts and Documents* (Cambridge, MA & London: MIT Press, 2002) p. 316.
30. Clark, T.J.: "For a Left With No Future", p. 75.
31. Ibid., p. 75.
32. This being the by-now classic example of what Mark Fisher dubbed "capitalist realism" in his short pamphlet from 2009: *Capitalist Realism: Is There no Alternative?* (London: Zero, 2009). Fisher builds part of his description on Fredric Jameson's and Slavoj Žižek's often quoted statement about the inability to conceive of another society. "It seems to be easier for us to imagine the thoroughgoing deterioration of the earth and of nature than the breakdown of late capitalism." Jameson, Fredric: *The Seeds of Time* (New York: Columbia University Press, 1994) p. xii.
33. Jameson, Fredric: "Postmodernism and Consumer Society", in: Foster, Hal (ed.): *Postmodern Culture* (London: Pluto Press, 1985) pp. 111–125.
34. Nora, Pierre: "Reasons for the Current Upsurge in Memory", in: *Eurozine*, 19 April 2002; http://www.eurozine.com/articles/2002-04-19-nora-en.html
35. Brecht, Bertolt: "Solidaritäts Lied", in: Gersch, Wolfgang & Hecht, Werner (eds.): *Kuhle Wampe. Protokoll des Films und Materialien* (Frankfurt: Suhrkamp, 1973) p. 62.

Rebel Rebel
Chris O'Leary
David Bowie: every single song. Everything you want to know,
everything you didn't know.
Paperback: 978-1-78099-244-0 ebook: 978-1-78099-713-1

Cartographies of the Absolute
Alberto Toscano, Jeff Kinkle
An aesthetics of the economy for the twenty-first century.
Paperback: 978-1-78099-275-4 ebook: 978-1-78279-973-3

Malign Velocities
Accelerationism and Capitalism
Benjamin Noys
Long listed for the Bread and Roses Prize 2015, *Malign Velocities*
argues against the need for speed, tracking acceleration as the
symptom of the on-going crises of capitalism.
Paperback: 978-1-78279-300-7 ebook: 978-1-78279-299-4

Meat Market
Female Flesh under Capitalism
Laurie Penny
A feminist dissection of women's bodies as the fleshy fulcrum
of capitalist cannibalism, whereby women are both consumers
and consumed.
Paperback: 978-1-84694-521-2 ebook: 978-1-84694-782-7

Poor but Sexy
Culture Clashes in Europe East and West
Agata Pyzik
How the East stayed East and the West stayed West.
Paperback: 978-1-78099-394-2 ebook: 978-1-78099-395-9

Readers of ebooks can buy or view any of these bestsellers by clicking on the live link in the title. Most titles are published in paperback and as an ebook. Paperbacks are available in traditional bookshops. Both print and ebook formats are available online.

Find more titles and sign up to our readers' newsletter at http://www.johnhuntpublishing.com/culture-and-politics
Follow us on Facebook at
https://www.facebook.com/ZeroBooks
and Twitter at https://twitter.com/Zer0Books